IMAGES
of Aviation

MILLVILLE
ARMY AIR FIELD

AMERICA'S FIRST DEFENSE AIRPORT

D1260405

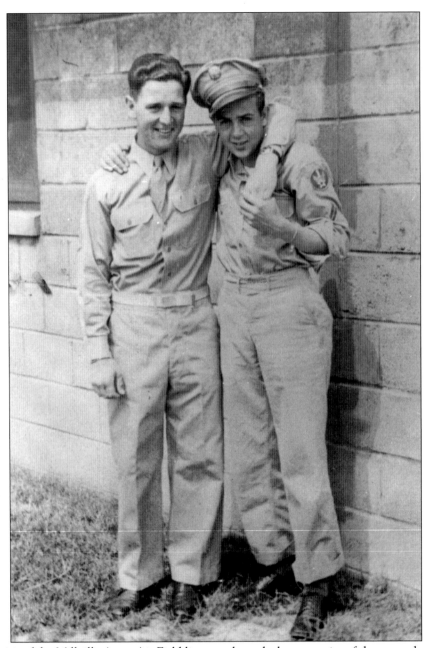

The spirit of the Millville Army Air Field lives on through the memories of the men who served there. Bob Goldstine (left) served as an airplane mechanic for the duration of the war at Millville and became one of the founding members of the Millville Army Air Field Museum. (Millville Army Air Field Museum.)

ON THE COVER: Officers of the office of post engineer pose for the camera at the Millville Army Air Field. It would take pilots, armorers, mechanics, and an army of pencil pushers to make the airfield go and to train men to accurately attack the enemy from the cockpits of their P-47 Thunderbolts. (Millville Army Air Field Museum.)

IMAGES
of Aviation

MILLVILLE
ARMY AIR FIELD
AMERICA'S FIRST DEFENSE AIRPORT

John J. Galluzzo for
the Millville Army Air Field Museum

ARCADIA
PUBLISHING

Published by Arcadia Publishing
Charleston, South Carolina

Printed in the United States of America

Library of Congress Control Number: 2010940242

For all general information, please contact Arcadia Publishing:
Telephone 843-853-2070
Fax 843-853-0044
E-mail sales@arcadiapublishing.com
For customer service and orders:
Toll-Free 1-888-313-2665

Visit us on the Internet at www.arcadiapublishing.com

Dedicated to all who served at Millville Army Air Field, military and civilian—especially the 14 men who gave their lives while training to fight for our country: 2nd Lt. Morgan J. Barton of Sheridan, Wyoming; 2nd Lt. William E. Canniff of Hackensack, New Jersey; Capt. Harold H. Crossley of East Templeton, Massachusetts; 2nd Lt. Robert G. Derwent of Trenton/Princeton, New Jersey; flight officer John F. Driscoll of Van Horn, Iowa; 2nd Lt. Andrew J. Easterwood Jr. of Dadeville, Alabama; 2nd Lt. Earle Hepburn Jr. of Merion Station, Pennsylvania; 1st Lt. William S. Malone of Waukesha, Washington; Flight Officer Ceylon R. Morrison of Niagara Falls, New York; 2nd Lt. Lee L. Pryor Jr. of Calhoun City, Mississippi; 2nd Lt. John D. Rumbaugh of Millersburg, Ohio; 2nd Lt. William D. Slater of Cambridge, Massachusetts; 2nd Lt. James F. Thompson of Portsmouth, Virginia; and 2nd Lt. Charles M. Weber Jr. of Muscatine, Iowa.

CONTENTS

ACKNOWLEDGMENTS

The story of the Millville Army Air Field is too deep and too rich for any single author to claim he could tell on his own, especially without the assistance of the staff and volunteers of the museum dedicated to relating the tale. This book was made possible by the following individuals: Lisa Jester, executive director of the Millville Army Air Field Museum; Donna Vertolli, museum board member/public relations; Joyce Lazarcheck; and Joan Legg. Volunteers who shared invaluable time and knowledge with the author included John Flint, museum board member/historian; Jim Vertolli, a founding member and past president of the Millville Army Air Field Museum; Andy Kondrach, a founding member and chairman emeritus of the Millville Army Air Field Museum; and Ron Frantz, who helped the author nose in while he took a turn in the museum's rare, fully operational Link Trainer. Dale Wettstein of Steelman Photographics offered important imagery, as did Bob Francois and the Millville Historical Society and Lois Abbott, diligently working to preserve the history of the lost village of Baileytown. Penny Watson of Watson & Henry Associates provided the link that connected the author to the museum. Despite the large number of individuals who participated in the project, any faults found in this book revert to the blame of one man, the author.

Unless otherwise noted, all images appear courtesy of the Millville Army Air Field Museum.

INTRODUCTION

What manner of courage did it take to volunteer to fly and fight for the United States during World War II? The country had been in a state of isolationism since the end of the First World War. The standing army, especially during the Great Depression, was short-staffed, underfunded, and decidedly weakly armed. Men drilled with fake wooden rifles, even practicing "firing" without any bullets, going through the motions in attempts to at least keep alive a hint of the skills that would be needed in a time of war. Despite growing belligerence by both Germany and Japan—and even Italy—in the latter half of the 1930s, most American citizens saw war as something taking place in other parts of the world, something that would never involve their country so long as their government remained neutral. In a country of, by, and for the people, they felt this arrangement could go on forever.

Then came December 7, 1941.

A generation of fathers who had marched off to fight for their country in the forests of Europe in the First World War watched as the next generation, their sons, rushed to recruiting offices and joined up to do their part to bring America's new enemies to their knees and back in line with the tenets of world peace. The Army, Navy, Marines, Coast Guard, and Merchant Marine competed for the best and the brightest to carry machine guns through Pacific jungles, fire torpedoes from submarines beneath the surface of the Atlantic, and load and fire huge cannons at coastal defense forts that dated back to the American Revolution. But for many a young man, the only way to wage war would be from above, from the cockpit of a fighter plane.

Man had only taken to the air by plane less than four decades earlier. The Wright brothers had proven the concept of manned flight with a 12-second, 120-foot hop in 1903 at Kitty Hawk, North Carolina. For the next two decades, pilots competed for speed and distance records. Aircraft evolved as flyers found new purposes for them: mail transport, acrobatics, and military tactics. Less than 25 years after the Wright brothers focused the world's attention on the sky, pilot Charles Lindbergh flew his plane across the Atlantic Ocean from New York to Paris. By the late 1930s, common wisdom dictated that any municipality worth its salt should have a local civic airport. In communities across the United States, bands of forward-thinking men and women formed flying clubs and began advocating for airfields.

Millville, New Jersey, formerly known as the region's glassmaking center but awash in a decade of mediocrity and sleepiness concurrently forced upon many similar towns by the economic crash of 1929, proved to be one of those communities reaching for the sky. The Millville Flying Club formed on November 9, 1939, just as the clouds of war began to gather over the United States. One member of the club sought training to gain a license and begin training others, the paramount key word for the club being *safety*. Immediately upon the close of the first meeting, the club forwarded maps of six potential sites within Millville to the US State Department for consideration for an airfield and strategized to purchase an airplane.

Forces already in motion, spurred by Germany's invasion of Poland on September 1, 1939, conspired to change Millville's fate forever. The luckily timed placement of a Millville native, Leon Henderson, high in the Franklin D. Roosevelt administration brought opportunity to the small town. The new Civil Aeronautics Administration (CAA) sought the creation of more than 900 airfields on the coasts of the United States capable of hosting, at a moment's notice, fighter plane units to defend the country should the wars raging in Europe and Asia attempt to cross the Atlantic or Pacific. Henderson jumped on the idea, championing Millville's proposal to be home to one of those airfields. In December 1940, the city commission agreed to the spending of $197,000 in CAA funds to improve the 604-acre airfield on the Millville-Cedarville and Buckshutem Roads. That work would include the paving of two 4,000-foot runways. Work began in February 1941, with a dedication in August announcing Millville as home to "America's First Defense Airport." Soon after that celebration, the CAA spent $265,000 more to expand the runways to 5,000 feet in length and from 100 to 150 feet in width. The Millville Airdrome was prepared to host 125 fighter planes.

Just a few months later, the civilian field welcomed the arrival of the 33rd Fighter Group, in a knee-jerk reaction to the bombing of Pearl Harbor. The unit came and left quickly, and the Millville Army Air Field underwent another quick transition. In May 1942, the Army Air Corps took command of the field and converted it for use as a gunnery training site for pilots flying Curtiss P-40 Warhawks and later Republic P-47 Thunderbolts. The Thunderbolt would become the undying symbol that connected Millville to the battlefields of World War II.

More than 10,000 people supported and trained at the base during the war, 1,500 of them pilots qualifying to move into combat. Fourteen pilots lost their lives training in Millville, the result of approximately 200 accidents that occurred on base between 1942 and 1945. The versatile P-47 called for expertise in aerial gunnery, dive-bombing, skip bombing, and even chemical warfare tactics. The men who flew and fought left their mark not only on airfield memorials but in the hearts of Millvillians who accepted them into their community, fed them, cared for them, and in some cases married them.

So what manner of man volunteered to fly and fight? Men like Bill Rich, Bernie Borelli, Jay "Herky" Thomson, Jean "Woody" Woodyard, and the others included in this book. Armed with the self-perceived invincibility of youth and confidence borne of hours of repetition in gaining the needed skills to master the P-47, they flew into battle on behalf of their fellow Americans, sometimes never to return. Their story is the story of the Millville Army Air Field, America's first defense airport.

One

THE MILLVILLE
FLYING CLUB

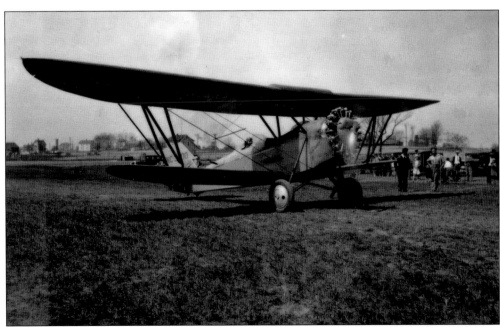

Planes had touched down in Millville long before the formation of the Millville Flying Club. Reporter Virgil S. Johnson remembered, in his "Ramblin' Round" column of the *Millville Daily* of October 11, 1974, when a plane settled onto Union Lake Park in 1914. In years to come, sights like this New Standard D-25 model standing at Coombs Field in 1930 were increasingly common.

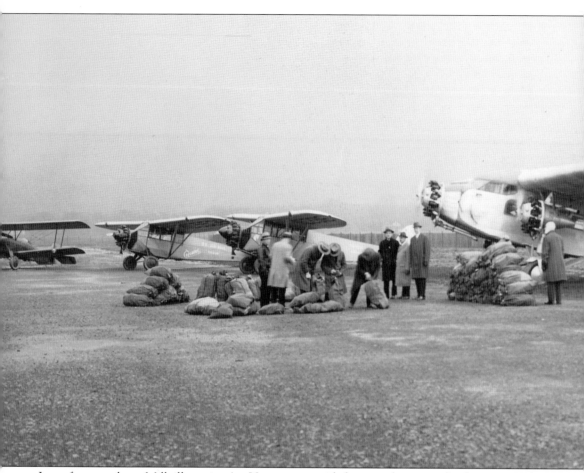

Just a few years later, Millville native Art Vanaman provided a special moment for the citizens of his hometown. An Army pilot, Vanaman informed Virgil Johnson that he would be flying over Millville on his way from Washington, DC, to New York City on a specific day in what Johnson surmised in his *Millville Daily* column years later was about 1917. As a baseball game played out behind city hall, Vanaman circled the field twice and dipped his wings, and his friends cheered

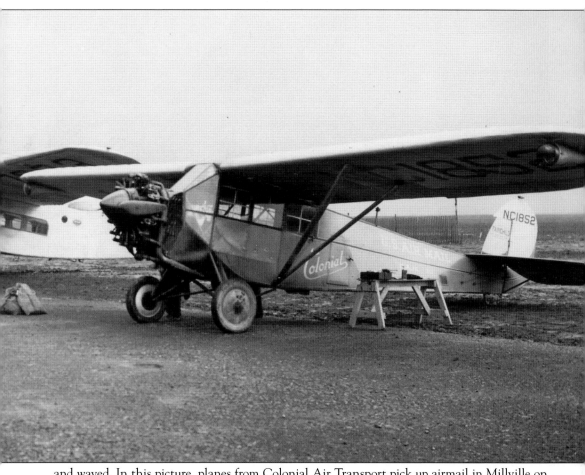

and waved. In this picture, planes from Colonial Air Transport pick up airmail in Millville on November 24, 1928. Colonial, financed by the Vanderbilt and Rockefeller families, among others, held the rights to Contract Air Mail Route 1, between Boston and New York. A version of the Fairchild FC-2 shown on the right is on display at the Smithsonian National Air and Space Museum in Washington, DC.

Millville's true love affair with aviation finally struck in 1939, when lawyer Nathaniel "Ned" Rogovoy and other local men chatting at a hamburger stand conceived of a flying club "to promote the progress of aviation" in Millville, to provide flight training courses and facilities, buy a plane or two, and develop an airfield. Rogovoy, a former standout football star at the local high school, became the first president of the club. He also became the first licensed pilot of the Millville Flying Club. The club met in November 1939, applied for the right to incorporate on December 22, and received positive notification to that effect from New Jersey secretary of state Thomas A. Mathis on January 2, 1940. With legalities conquered, the club could get down to the business of learning to fly under the guidance of its first instructor, Lewis Kroelinger.

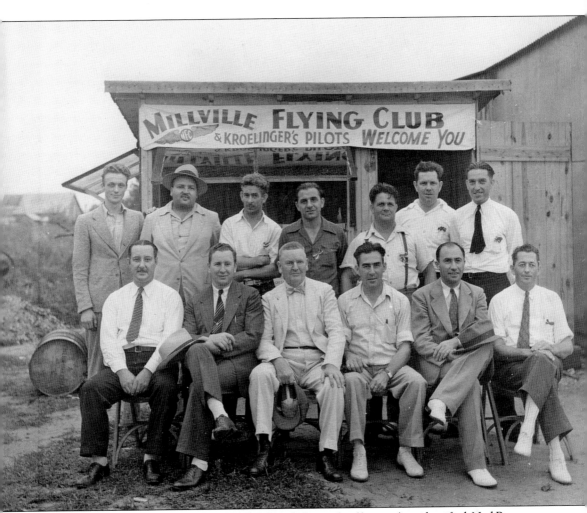

The early membership of the club included, from left to right, (first row) unidentified, Ned Rogovoy, Frank Wheaton Sr., Mayor Raymond Goodwin, Samuel Adler, and Norman Thompson; (second row) Loren Holmes, Emerson Steward, George Gressman, Joseph Genovese, Newell Oliver, Ambrose Clark, and Gus Schick. Wheaton, a businessman and philanthropist, was an honorary member, most likely a financial supporter. Early members not pictured included Dr. Bailey B. Abrams, Alfred Alfonsi, Leonard Branker, Rudolph Chalow, Peter Fioresi, Jack Gannon, James Giles, Walter Harvey Jr., John C. Ludlam Jr., Dominick Matteuci, G. Mead Thorpe, Earl M. Wescoat, and Earl S. Williams. Members came from all walks of life, some related to aviation, some as far removed as one could be: glassworkers, garage owners, mechanics, roofing contractors, a taxi driver, dentists, politicians, a trucker, a hosiery knitter, and even an aircraft worker.

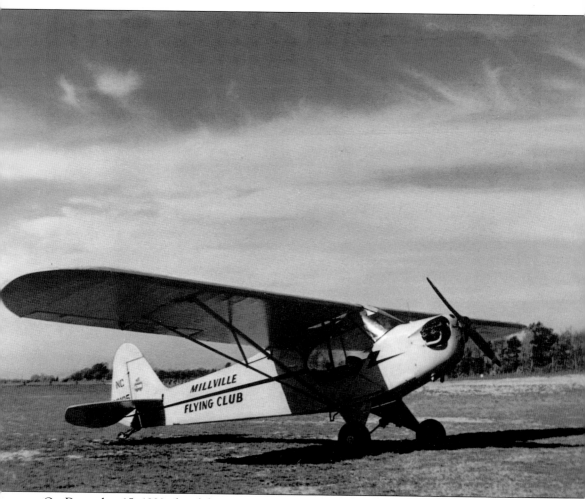

On December 15, 1939, the club announced the pending arrival of a new acquisition, its first plane. An unattributed newspaper clip in the files of the Millville Historical Society states, "A new Pieper [sic] Cub 55 trainer with Lycoming motor will be purchased through Larry Holmes and Donald Breeden. It will be fully equipped with the newest safety devices and will be delivered in approximately ten days. Instructions will be given by Lewis Kroelinger, Vineland, and the trainer will be kept at Kroelinger's airfield temporarily until such time as the Millville airport is ready for use. This proposed airport is located at Magee's farm on the Hogbin road. It has been approved and will be licensed by the New Jersey State Flying Commission in the near future." By New Year's Day 1940, the Millville Flying Club had quickly moved through several of its original aims.

Triumphs came quickly, as the club made itself not only newsworthy but also useful to the community. Here, members pose with the plane that provided aerial coverage of the devastating flood that struck southern New Jersey on September 1, 1940. By that time, the club had 19 members, 17 of whom had pilot's licenses. (Steelman Photographics.)

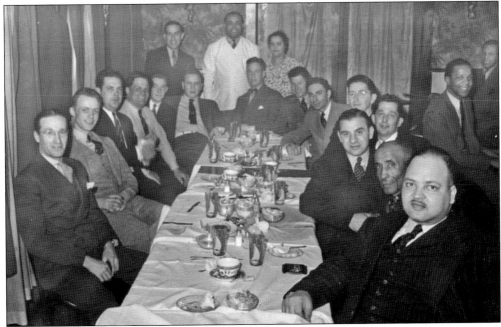

Like many other clubs, much of the enjoyment of membership included the simple camaraderie of sharing common interests. Conversations held off the airfield could be as stimulating as those held under the shade thrown by the wing of the club's Piper Cub. Here, members pause during dinner to be captured by the camera for posterity. (Millville Historical Society.)

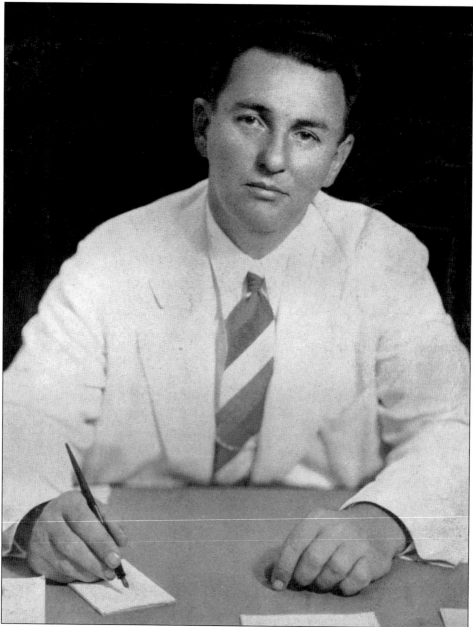

The work of the Millville Flying Club coincided with the rising threat of the United States' inclusion in a global military conflict, the first one that would prominently feature air warfare. In April and May 1940, Nazi Germany invaded Denmark, Norway, France, Belgium, Luxembourg, and the Netherlands. On August 13, German planes bombed factories in England for the first time. Their quick march across Europe put the United States in a defensive posture. Examining its coasts, the country saw a series of dilapidated and outdated coastal artillery sites and the serious need for airfields from which fighter planes could take off to meet enemies flying from across the seas. The National Defense Act of 1940, passed in June, called for the location and, if needed, construction of 900 such airfields. When he heard the news that Millville was being considered for one of the airfields, Leon Henderson, working in Washington, DC, quickly promoted his hometown.

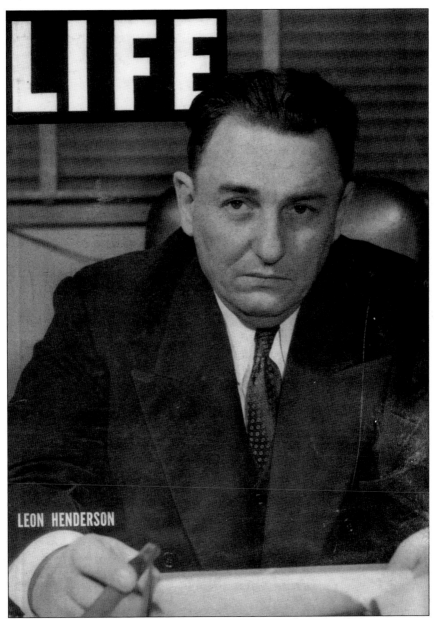

LEON HENDERSON

Born in Millville in 1895, Leon Henderson attended Millville High School and Swarthmore College before beginning a career in economics. Between 1925 and 1934, he worked for the Russell Sage Foundation, dedicated to the general improvement of living conditions across the United States. His work soon caught the eye of Pres. Franklin Delano Roosevelt, who appointed Henderson to head the Research and Planning Division of the National Recovery Act, the first of many government posts he would hold. In May 1940, he accepted an appointment to the National Defense Advisory Committee. Pulling whatever strings he had available, Henderson solicited a visit to Millville by Maj. Lucius Clay, the "yea and nay official on which city got airfields," as Henderson would later describe him. Impressed with the availability of land for what he termed inevitable expansion, Clay voted yes on Millville. On December 12, 1940, Millvillians received word that $197,000 would soon be spent on airfield improvements in town.

Workmen broke ground on February 22, 1941, the anniversary of George Washington's birthday. The early date meant that Millville was the first community to begin work on a field designated under the plan. The community proudly boasted that it was home to America's First Defense Airport. The club joined Mayor Gus LaDow (top) in celebrating the ground-breaking. (Steelman Photographics.)

Wherever the mayor went, of course, pomp and circumstance followed. A future hero could be seen as well. The Scout holding a bugle on the left is Lou Sharpless. Sharpless went on to make his own mark on World War II on behalf of his hometown as the pilot of a B-24 Liberator bomber. (Steelman Photographics.)

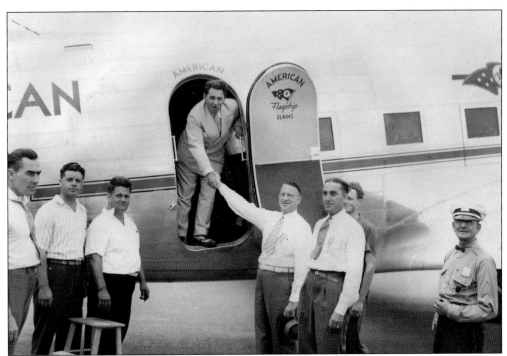

On August 2, 1941, after weeks of timber cutting, runway building, and even testing by the Millville Flying Club, the field was ready for inspection by the public and dedication. Several dignitaries would be on hand for the ceremony, including Brig. Gen. Art Vanaman and Leon Henderson, shown here deplaning to take his turn at the microphone.

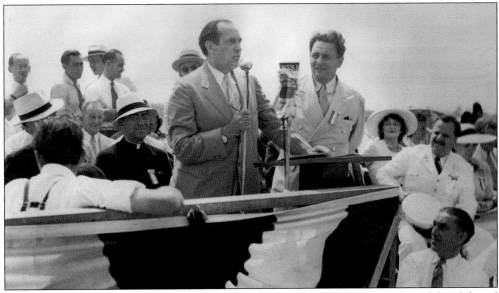

A crowd estimated at 10,000 people listened as Raymond Goodwin, a member of the club and the new mayor of Millville, emceed the event, introducing senators from New Jersey to Florida. Art Vanaman (left) spoke to his many admirers and friends in his hometown. He left his post as assistant air attaché in Berlin, Germany, in August 1941, taking his new post as secretary of the Air Staff for the Army Air Corps just in time to attend the dedication of the new field.

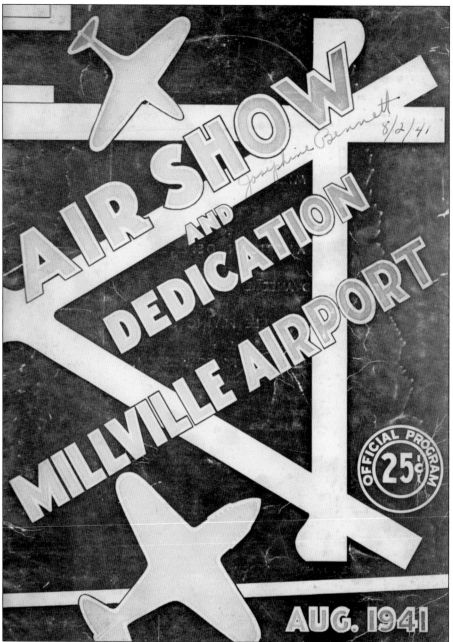

The dedication ceremony proved to be a culmination point for the Millville Flying Club, which would continue to thrive. The club had met all four of its goals—promoting aviation, providing training facilities, buying planes, and building an airfield—all within two years of discussing the concept over a couple of hamburgers. On August 2, 1941, Sherwood A. Cole put on a fantastic air show for the gathered crowd, including a parachute jump from two miles into the sky, a breathtaking sight for the many folks who had been born in a time before automobiles and planes. Thirty-five pilots took to the air together in a mass flight over the field. Forest fire crews demonstrated how they coordinated air and ground forces in assaults on conflagrations, foreshadowing events to come at Millville.

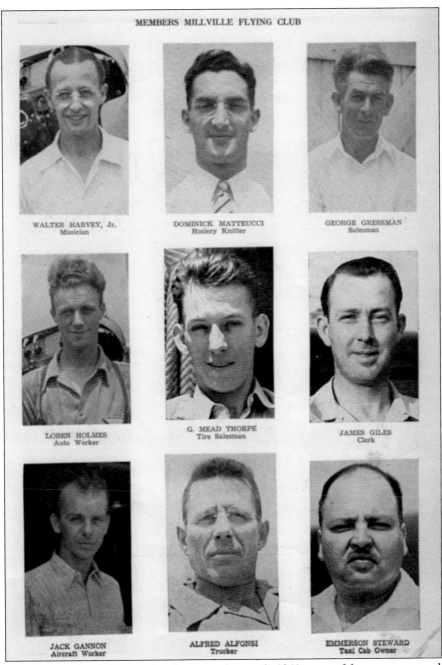

WALTER HARVEY, Jr.
Musician

DOMINICK MATTEUCCI
Hosiery Knitter

GEORGE GRESSMAN
Salesman

LOREN HOLMES
Auto Worker

G. MEAD THORPE
Tire Salesman

JAMES GILES
Clerk

JACK GANNON
Aircraft Worker

ALFRED ALFONSI
Trucker

EMMERSON STEWARD
Taxi Cab Owner

The headshots in the dedication brochure on August 2, 1941, were of faces seen around town on a normal basis. The average passerby might never have known that his or her car mechanic was also a pilot, but a glance in the brochure confirmed that he at least had a connection to the new airfield, and that set him apart from most other people in town. He had brought aviation permanently to Millville and helped to raise the profile of the community searching for a new identity. But with all the excitement of the arrival of the new age for Millville came the passing of an older one. The Millville that many people once knew, the one dedicated to pastoral pursuits, was soon to go away.

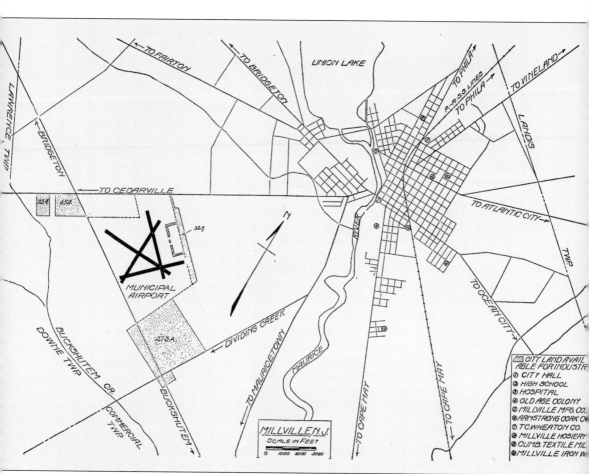

Maj. Lucius Clay's prediction of expansion of the airfield proved to be prescient. Shortly after the dedication of the airfield, the federal government called for the two 4,000-foot runways to be extended to 5,000 feet each and for two more runways to be built. More land would be purchased for gunnery ranges, and in that process, an entire village disappeared. With the consumption of 18,000 acres south of the airfield, an area consisting of 20 square miles, Baileytown vanished. Millville and the surrounding towns had industrialized decades in the past, with large factories attracting workers to the town centers and helping the growth of the communities, but the march away from America's agrarian past had been slow. With the taking of large swaths of land, specifically farmland, the Millville Air Field hastened that transition. Where crops once grew, mock targets would soon stand; where the roar of a water-powered mill was once heard, bullets tearing through the sky would sound off.

The pictures on this page possibly represent the Ned Rogovoy home on Bridgeton Road. Millville's early pilots delighted in the new perspectives of the air and in the ability to take photographs from the cockpits of planes of familiar landmarks. Their efforts were pioneering, as few people had ever flown over Millville.

But the pictures were also important from the perspective of history. Each picture captured a moment in time that was soon to be irretrievably lost. For the next few years, hundreds of military pilots would see these same sights, the last days of large-scale farming in Millville.

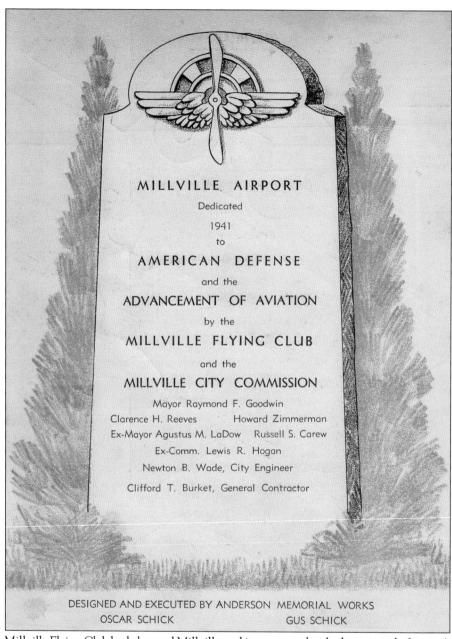

MILLVILLE AIRPORT
Dedicated
1941
to
AMERICAN DEFENSE
and the
ADVANCEMENT OF AVIATION
by the
MILLVILLE FLYING CLUB
and the
MILLVILLE CITY COMMISSION
Mayor Raymond F. Goodwin
Clarence H. Reeves Howard Zimmerman
Ex-Mayor Agustus M. LaDow Russell S. Carew
Ex-Comm. Lewis R. Hogan
Newton B. Wade, City Engineer
Clifford T. Burket, General Contractor

DESIGNED AND EXECUTED BY ANDERSON MEMORIAL WORKS
OSCAR SCHICK GUS SCHICK

The Millville Flying Club had changed Millville and in a tremendously short period of time. As the country faced war, the prospects of jobs, prosperity, and a return to a comfortable, pre-Depression life arose. Moving into this brave new world came with sacrifices, some even more important than land. Just four months after the dedication of the Millville Air Field as America's First Defense Air Field, Japanese planes attacked and bombed Hawaii's Pearl Harbor. Millvillians, like millions of other Americans across the country, wondered exactly what it all meant. The locals, though, found out sooner than most, when rumors of military planes headed for the airfield began to fly. With the unveiling of a memorial to the club provided by member and stonecutter Gus Schick, the contributions of the club were permanently proclaimed. With the completion of the airfield, Millville would never be the same.

Two

MILLVILLE
ARMY AIR FIELD

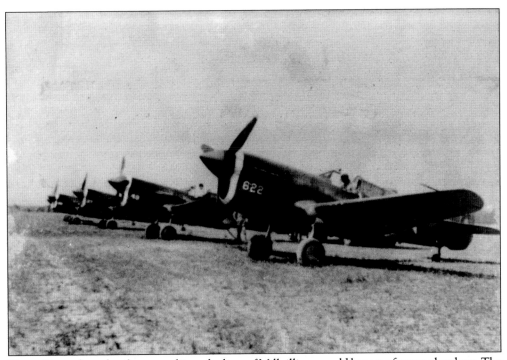

The military plane that first soared into the lives of Millvillians would become famous elsewhere. The Curtiss P-40 Warhawk arrived with the newly renamed 59th Fighter Squadron of the 33rd Pursuit Group in the spring of 1942, a reactionary move by the country to strengthen defense along the coasts in the wake of the Pearl Harbor attack. Their visit was short-lived; by November, the entire group had moved on to North Africa. For Millville, though, World War II had commenced.

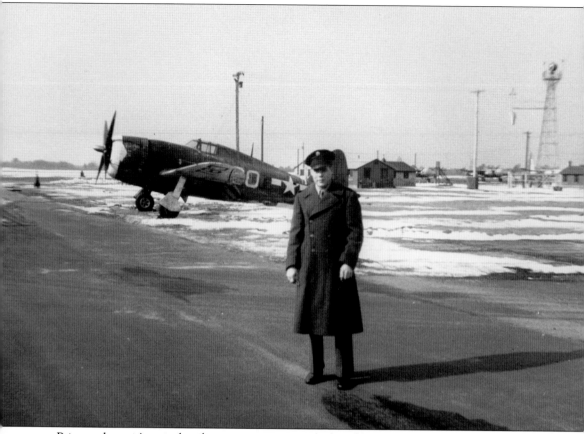

Prior to the unit's arrival, military activity, some of it bewildering, began to take place. Civilians sworn to secrecy appeared on the base and began building sandbag structures just days after Pearl Harbor, and soon soldiers from Indiantown Gap, Pennsylvania, took over the task. The Army Air Corps arrived on the base in May 1942 in the form of the 33rd Pursuit Group, redesignated the 33rd Fighter Group that same month, and heralded the transition of the base from a defense field to a gunnery training field. Although the first few visits to the field proved to be of short duration, a few weeks at a time, the day soon came when the P-47 Thunderbolt, shown here, and not the P-40 Warhawk, would become a regular resident of Millville.

Those early days of training, though, came without the benefit of solid structures for the pilots and ground crews to call home. Instead, the members of the 59th Fighter Squadron lived in tents when they trained at Millville. Here, they prepare to leave for Philadelphia on May 23, 1942.

The orderly room for the 59th was simply another tent, as shown here between May 13 and 23, 1942. The men who trained at Millville in those early days would go on to hone their skills in combat in the various theaters of the war in the years to come. The P-40 itself would become well-known for its agility and durability in North Africa, China, and the South Pacific, and in use by the Russians, Brazilians, French, English, and Mexicans.

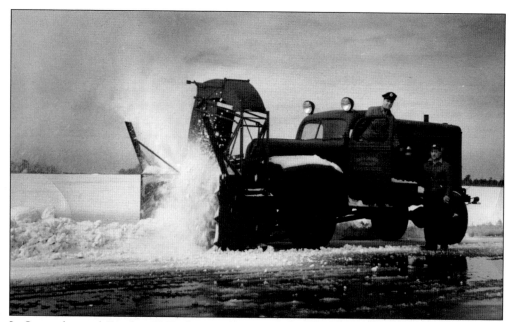

In September and October 1942, the new base began to take shape as the gunnery school idea moved from concept to reality. More land purchased from local owners led to expansion in anticipation of bombing practice runs to begin in January 1943. Cinder-block buildings rose as winter rolled in.

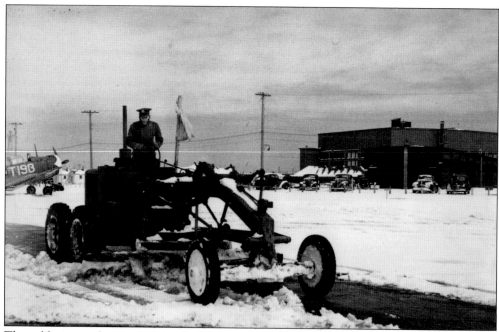

The cold winter of 1942–1943, battled here by Lt. Willard D. Harris on a snow scraper, exposed the P-40. The 58th Fighter Group, which arrived in January 1943 as an overseas training unit, or OTU, struggled with ice and snow removal, often damaging the planes. Several times, gunnery training had to be cancelled altogether. The 351st Fighter Group, which followed the 58th into base, transitioned from the P-40 to the army's newest, more capable fighter, the P-47.

Snow would not be the only meteorological enemy to the fliers of Millville. The low-lying lands would be prime victims for floods, such as the 9.6-foot surge that wreaked havoc along the New Jersey coastline during the hurricane of September 1944. At such times, most pilots took their planes to other fields outside of a storm's path in a hurricane retreat. Not every plane made it out every time.

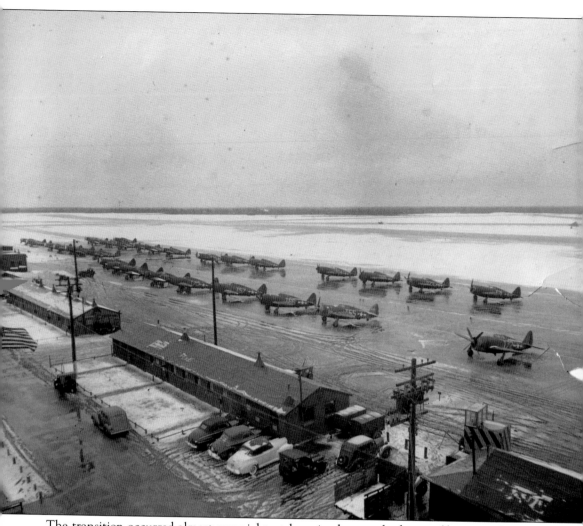

The transition occurred almost overnight, at least in the grand scheme of history. The P-40 Warhawk pilots went on to fight for their country, and the P-47 jockeys flew in to take over their bunks in Millville. A winter photograph taken of the taxiway shows the Thunderbolts ready for action despite the snow cover. As durable as the P-40 was, the P-47 could take even more of a pounding and would, in years to come, strike fear in the hearts of enemy pilots at first sight. No longer would the Messerschmitt 109 and Focke-Wulf 190 have clear advantages over American pilots in the skies over Western Europe. The air-cooled engine of the P-47 offered unparalleled diving capabilities, allowing pilots to reach amazing speeds prior to the jet age, and offering the army a tactical bonus—the ability to fly the planes as either dogfighters or dive-bombers.

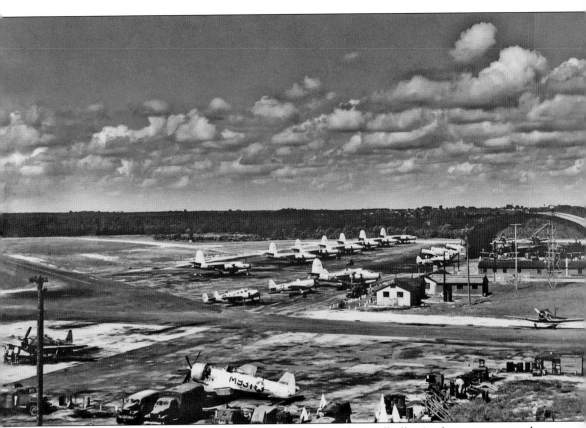

Dive-bombing became just one of the gunnery skills honed at Millville. As the war progressed, instructors taught pilots ground gunnery, aerial gunnery, skip bombing, dive-bombing, and even chemical warfare. The official base history explains just how thorny the construction of the ranges was. "The difficulties encountered by the officers in building the range were legion. Surrounding the targets were thick wooded areas. The pilots when strafing and dropping their bombs set sparks flying which caused innumerable forest fires and incalculable damage to the surrounding territory. The Area Engineers were called in and work was begun to clear the timberland for miles around." Occasionally, guns fired on farmhouses and down city streets, luckily without causing loss of life. An early commanding officer requested that the civilian population steer clear of the base, noting that the young men learning to fly the planes were doing just that, learning. One civilian laborer working on the base, Giuseppe Ricciuto, was killed on May 23, 1942, when struck by a moving plane.

With the construction of barracks, a headquarters building, and the many other structures necessary to the working life of a base came the realization that life could not consist of regimented training every hour of the day for young men torn from their homes with no guarantee of ever returning to see their loved ones. Of the buildings still standing today at the old Millville Army Air Field, the base theater may hold the most stories. The theater, shown here in 1944, helped create a true sense of community. The needs of the war unfortunately meant short training cycles and rapid deployment early in the war, which could lead to poor morale. On the other hand, the ability for the local men to show off their singing, dancing, and acting talents in shows like *Prop Wash*, developed and performed by the men on base with the help of local civilian girls, made the whole process more bearable. One actor, Grayson Enlow, served at Millville before going off to the biggest role of his career as Lamont Cranston, the alter ego of radio's famous Shadow.

Again, changes took place quickly at Millville. In September 1943, the army discontinued the formation of overseas training units (OTUs) and initiated the creation of replacement training units (RTUs). In January 1944, the base was elevated from a sub-base under Camp Springs in Maryland to a full, autonomous army base. That designation led to better services, like a post office.

The headquarters building, shown here from the rear, served as the nerve center of the airfield.

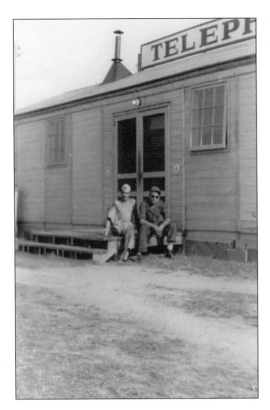

For the most part, with 10,000 people passing through the base in three years, there was always someone with whom to talk, but should one need to call home, or elsewhere, that privilege could be extended.

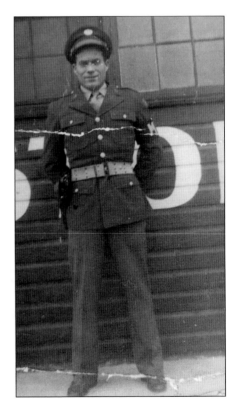

Military policemen, represented here by MP Virgil Webb, performed their duties from the building that is now the Flightline Restaurant. Prisoners under their supervision kept the base clean by picking up trash, washing windows, and taking on odd jobs that would otherwise take time away from other essential personnel.

The armament hut served exactly the purpose stated in its name. Lest one forget that the pilots here had already passed flight training and were working on the next steps to combat, the sights of men loading .50 caliber machine guns and fixing bombs, and eventually even rockets, to P-47s would jog the memory.

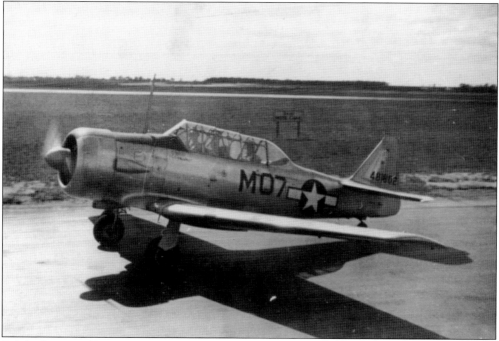

While the P-47 ruled the skies over Millville, other trainers, like this AT-6, could be seen as well. The single-engine advanced trainer allowed an instructor the opportunity to move beyond the classroom and take pilots learning to dive on targets into the sky.

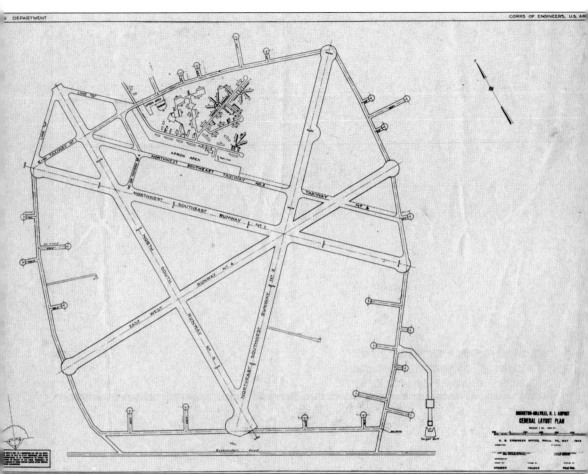

This general layout map from the US Engineer Office in Philadelphia shows a bare-bones snapshot of the Millville Army Air Field as it looked in 1943. The wide apron area standing above the northeast-southwest taxiway is represented in the pictures on pages 29 and 30. The four crisscrossing runways comprised most of the base, yet most of the life was concentrated in the many buildings by that time constructed, a portion of what was to come in 1944. While the map does tell a fair amount about the base, it does not even hint at its reach. The gunnery ranges, strewn across fields to the south of the base beyond Buckshutem Road, which runs across the bottom of this map, are not represented here.

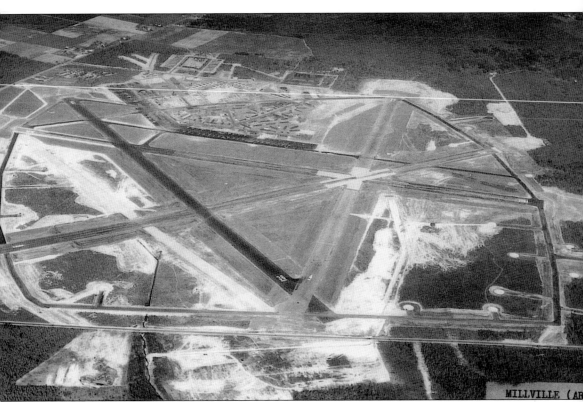

MILLVILLE (AF

Lt. Col. T.H. Watkins and post engineer Capt. J.E. Aebischer jointly announced a $700,000 building program designed to "change and alter every feature of the post" on May 15, 1944. "The Plans included the erection of a fully equipped hangar, eight warehouses, parachute building, 10 latrines, and the conversion of the officers' quarters to EM barracks. A new area was to be designated as the Officers' area, and that would include a new series of 'BOQs,' a mess hall, and an officers' Club." The Millville Army Air Field that the servicemen had come to know in 1942 was gone, improved in 1943. That Millville Army Air Field expanded upon itself in 1944, the time of this aerial photograph. While the expenditure needed to create and enhance such facilities might have seemed to state that war was here to stay, the men and women working on base could do nothing but enjoy the positive changes.

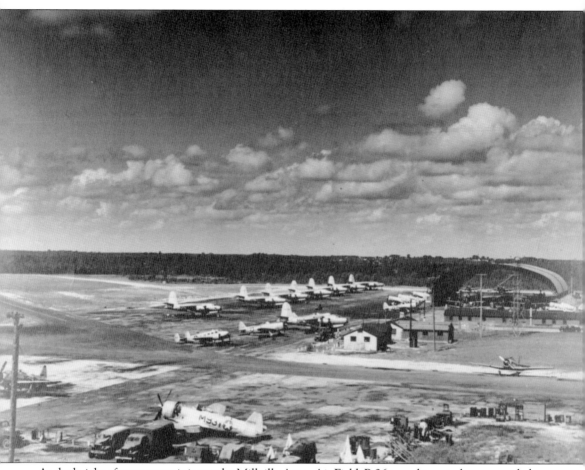

At the height of gunnery training at the Millville Army Air Field, B-26 towed target planes provided special training opportunities. These stripped-down versions of the B-26 Marauder bombers, shown here lined up at the top of the image, towed aerial targets at which the fighter pilots would shoot. Historian Bill Hogan wrote in the *Thunderbolt*, the newsletter of the Millville Army Air Field Museum: "their streamlined shape and powerful engines gave them a speed suitable for the job. In the forward waist area they carried a compact cable winch and sandbags were stacked in the tail. These bags compensated for the shift in the center of gravity with the loss of the top turret and were handy if a bullet went astray from a target attacking fighter or bomber."

The men who flew and fought in P-47 Thunderbolts lovingly called them "Thuds" for short, or a pilot might mention even the word "jug." This term, which confused British pilots took as an abbreviation for "juggernaut," actually reflected the American pilots' reference to the nose of the plane reminding them of milk jugs.

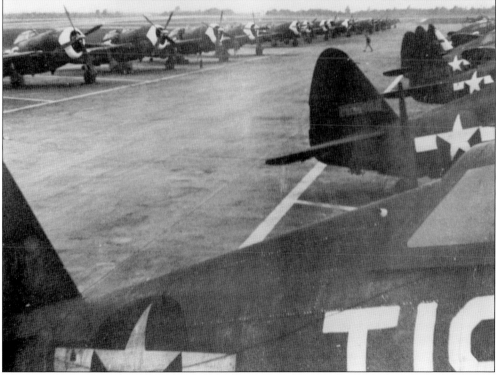

No matter what it was called, the P-47 had one important task to carry out over all others: bringing its pilots home alive. To that point, it was the biggest, heaviest, most expensive fighter plane to that point in American history, weighing as much as 17.500 pounds when fully loaded for combat.

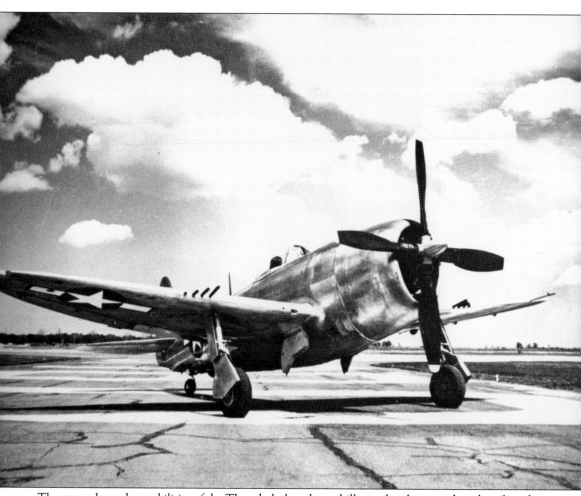

The ground attack capabilities of the Thunderbolt—those skills taught, sharpened, and perfected at Millville—remained so vivid in the memories of future aircraft designers that a second plane, the A-10 Thunderbolt II, carries its name in remembrance. Excellent in a roll but lackadaisical in a low-altitude climb and slow in turns, powerful in a dive and armed to the teeth with everything from machine guns to rockets, the P-47 went on to become one of the true technological triumphs of American fighter plane construction in World War II. Republic Aviation provided the planes, and Millville trained the men that helped bring back peace. Unfortunately, not every plane and not every man would return home from combat overseas. Some, in fact, never left Millville.

Three

ACCIDENTS
AND TRAINING

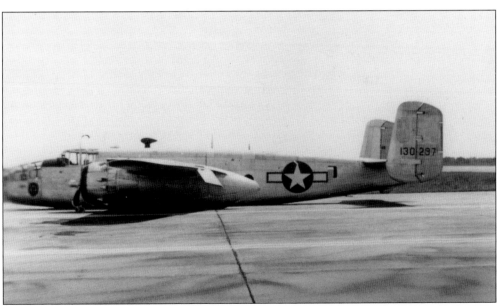

Especially in the early days of the war, the United States could not afford to lose either men or machines. But with young men just recently graduated from high school jumping behind the controls of war planes of brand-new designs coming fresh off assembly lines, one might argue losses were inevitable. Millville, sadly, saw its share of crashes. In some cases, men walked away unscathed, and their planes flew again. In other instances, neither was so lucky.

A case involving the injury of nothing more than pride occurred on August 17, 1945, days after the war had ended. Brig. Gen. John R. Hawkins, commander of the First Air Force, landed this B-25 Mitchell bomber at Millville to make a surprise inspection. "The official report," states historian Michael Stowe, "indicates that the landing gear collapsed due to material failure, but it was a very common error to pull up the landing gear, instead of the flaps." Whether it happened due to pilot error or mechanical failure, the slamming of the 10-ton plane onto the ground must have left ringing in the ears of many of the men standing nearby. Two years later, in October 1947, a Hawkins-piloted C-47 Skytrain crashed in Peru, setting off a massive search for the pilot and six other passengers. Hawkins was in charge of the US military mission to that nation.

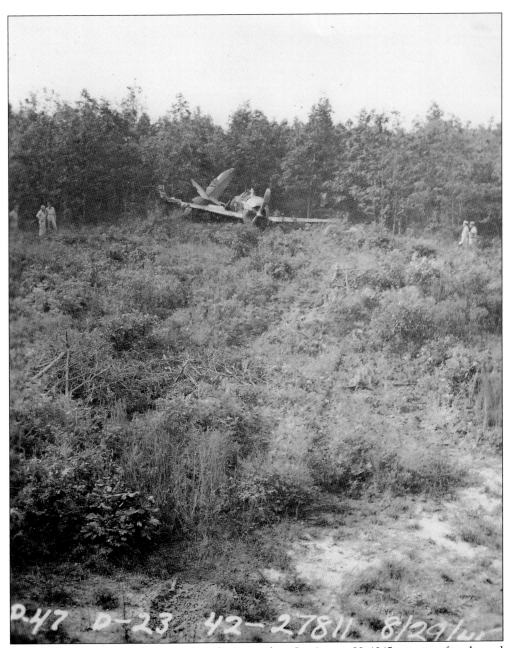

P-47 D-23 42-27811 8/29/4?

Sometimes pilots survived one wreck to die in another. On August 29, 1945—again, after the end of World War II—1st Lt. Elliot D. Ayer crashed this P-47 Thunderbolt, serial number 42-27811, at Millville. His was one of 37 American military plane crashes, four of which involved P-47s, that day alone around the United States. Miraculously, despite obvious heavy damage to the plane, Ayer lived to fly and fight another day. From Hartford, Connecticut, he was a combat veteran, having flown in campaigns over the Po Valley in northern Italy and the northern Apennines in southern France. As if that had not been enough excitement, he had another colorful location to put on his resume. Having enlisted in the regular army in 1939, he was stationed as an aircraft approach controller at Pearl Harbor, Hawaii, on December 7, 1941.

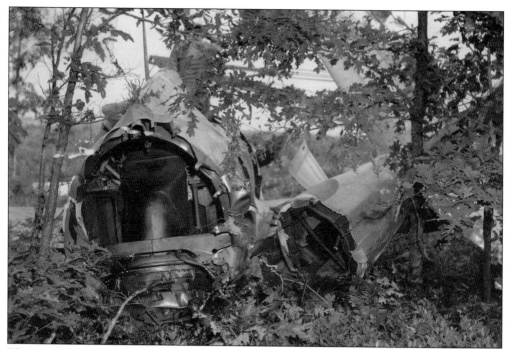

The twisted remains of Ayer's P-47 at Millville could not have foretold the future he had beyond that date. Ayer continued to fly into the next war, serving with the 67th Fighter Bomber Squadron in Korea.

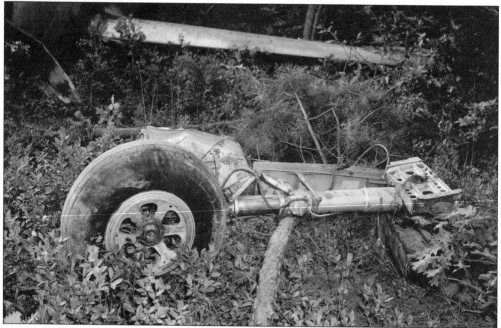

For his fantastic record in combat, including the awarding of his first Distinguished Flying Cross in August 1944, Ayer was chosen for a singular honor. On July 9, 1952, landing as the fourth pilot in a four-plane patrol, he logged the 45,000th sortie flown by the 67th Fighter Bomber Squadron in the Korean War.

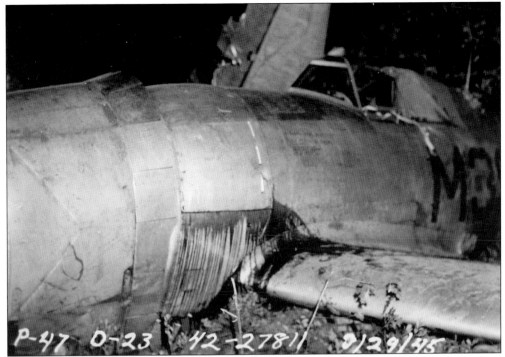

The 45,000th sortie represented the most flown by any unit in the war. Unfortunately for Ayer, fate would finally catch up with him.

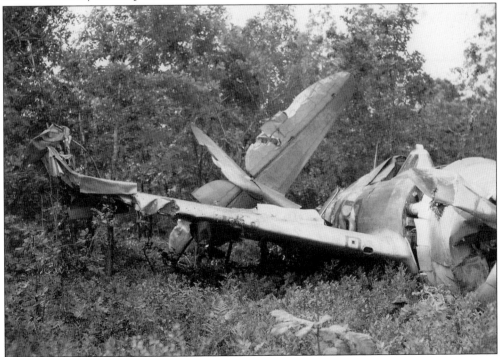

Just 16 days later, Ayer went missing in action; his remains were never recovered. He was the last known P-51 Mustang pilot to die in combat with the US Air Force.

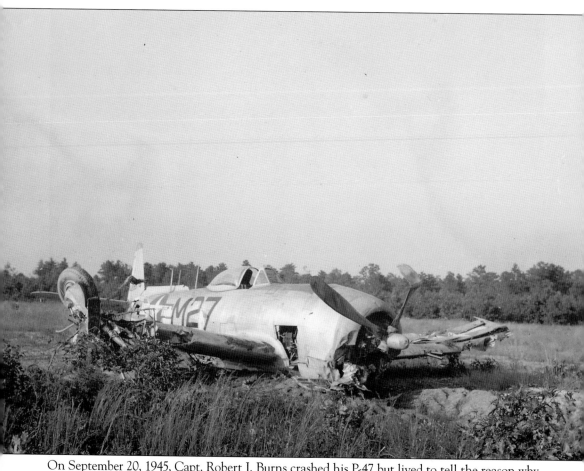

On September 20, 1945, Capt. Robert J. Burns crashed his P-47 but lived to tell the reason why. "I approached runway 30 with three other ships," an Army Air Force term for the planes. "While in turn from my base leg of the landing pattern, my left foot became wedged between the rudder pedal and the foot guide on the floor board section. This made me unable to apply opposite rudder to recover from the turn, thus enticing a roll to the left. I applied throttle to aid my recovery but the engine sputtered and did not catch until just before the aircraft hit the ground. During this time I tried to jerk my left foot out of the shoe and did so just before contact with the ground."

On August 31, 1945, over Ocean City, 2nd Lt. Charles C. Brooks's P-47 was involved in a mid-air collision and bore scars as proof. By that time, the war had come to an end, but Millville was still, if temporarily, fully training replacement pilots.

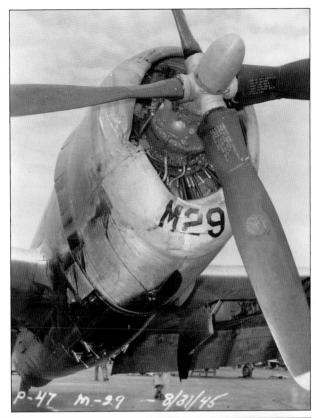

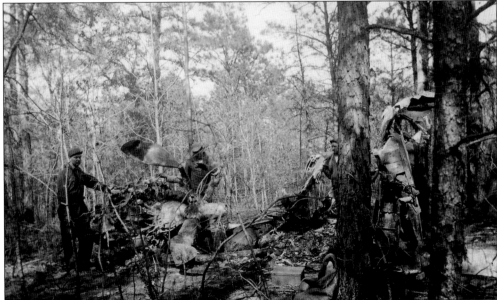

Of all the highs and lows that came with military life, there could be none more low than that moment of finding the wreckage of a plane that claimed the life of a friend and fellow flier. Pieces of planes wrecked on training missions from the Millville Army Air Field are still being found in the woods to this day.

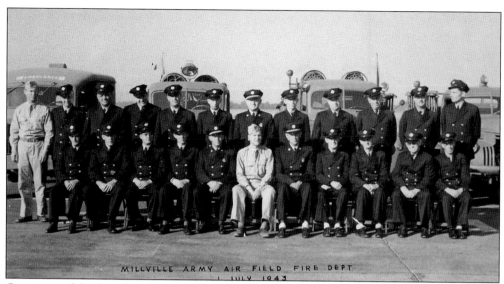

Cognizant of the fact that fires might, and probably would, occur both on airfields and, in the case of Millville, the surrounding woods, the Army Air Corps organized base fire departments. The Millville Army Air Field Fire Department poses here on July 1, 1943.

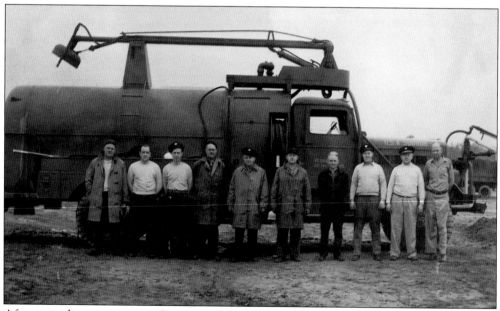

After struggling to convince Congress of the need for up-to-date machinery like most of the American military in the 1930s, military firefighters saw an influx of new equipment. The Class 150 Sterling Cardox Crash Truck held 6,000 pounds of low-pressure carbon dioxide that could be blasted out within 58 seconds. Pistol grips operated from the passenger's seat allowed the crew chief to manually control all of the engine's fixed nozzles.

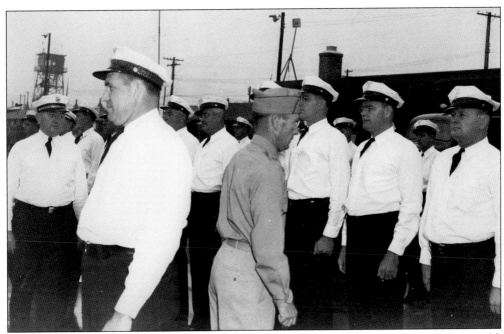

While the firefighters at Millville required specialized knowledge brought from the civilian world, they still maintained military order. Each base commanding officer designated a post fire marshal, or chief. Crews worked in opposite 12- or 24-hour shifts, working on fire prevention and fire safety education when not fighting fires.

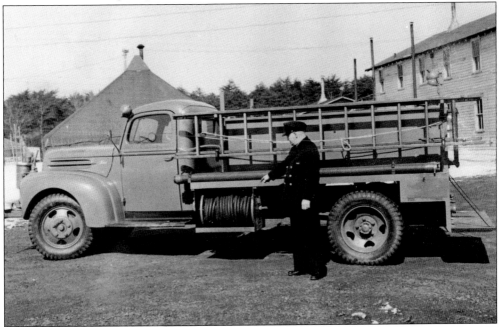

Charles Roedel served as fire chief at Millville and is shown here inspecting the base's Class 135 Crash Truck. Always concerned with improving the response time of his crews, Roedel earned a $50 check from the Army Air Corps for an innovative signaling system on the firehouse that told his firemen, as well as others on base, the runway on which a crash had occurred.

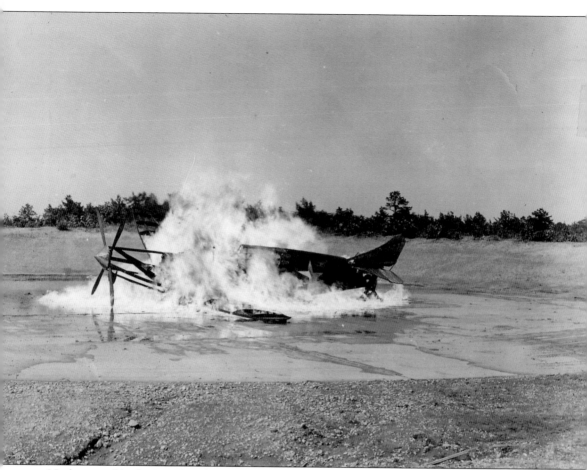

Nothing could substitute for a live training exercise. Here, on June 19, 1944, a P-47 Thunderbolt burns in a controlled fire.

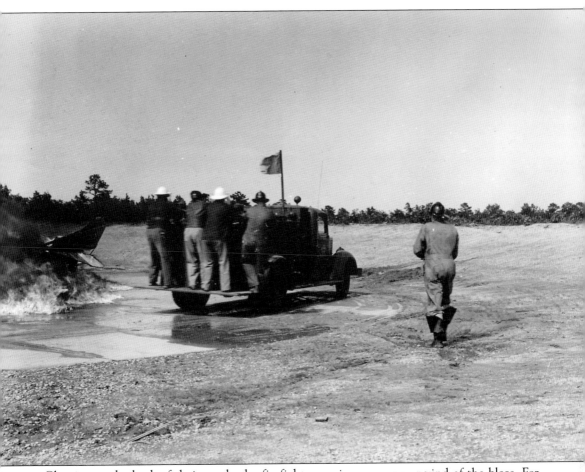

Clinging to the back of their truck, the firefighters arrive on scene upwind of the blaze. For efficiency's sake, each man has a predetermined role that he will execute in conjunction with those of the others.

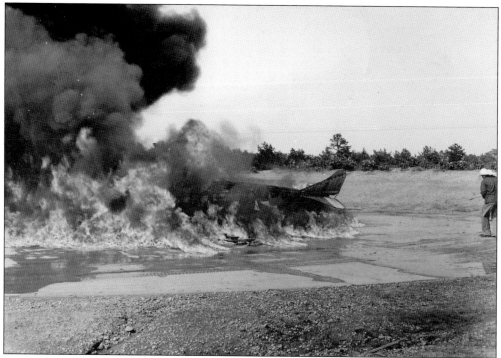

As the fire bellows black smoke into the sky, firefighters approach with the nozzle focused on the ground.

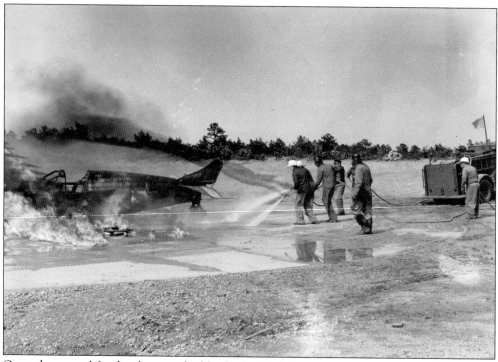

Once the ground fire has been pushed back, the firefighters can concentrate on attacking the flames on the plane itself.

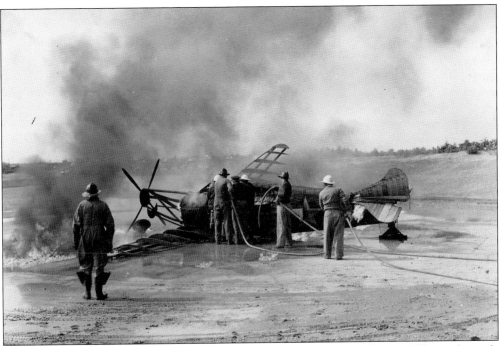

As small fires dance at their feet, firefighters work to extinguish any flames still at work inside the cockpit, as Fire Chief Roedel looks intently on. The stressed skin of the wings burned quickly, exposing the two spars and their numerous supporting stringers.

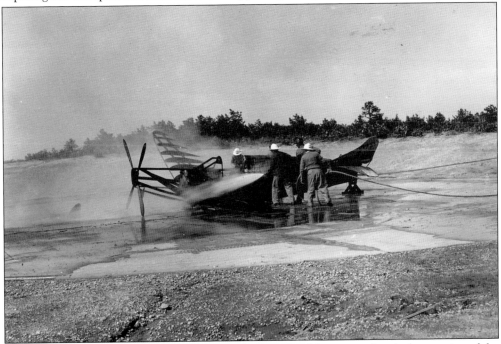

As the drill comes to an end, the firefighters do their due diligence and soak the remains of the plane from prop to tail, both of which suffered severe damage. Aside from the physical act of fighting a fire, the men gained specific knowledge of how a P-47 Thunderbolt burned from such drills.

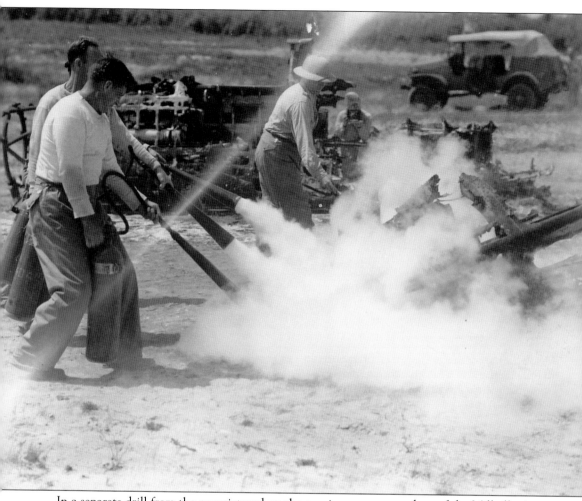

In a separate drill from the one pictured on the previous pages, members of the Millville Army Air Field Fire Department approach a small fire with extinguishers. Most extinguishers during the World War II era featured the use of carbon tetrachloride, an agent since found to be deadly when absorbed through the skin in large quantities and increasingly toxic when heated. These men, though, are using a combination of carbon dioxide and foam specially mixed to douse fires burning on aviation fuel spills. Of particular interest in this photograph, aside from the Army Air Corps photographer snapping pictures in the background, is the complete lack of fire retardant gear being used by the firefighters. Safety regulations have changed drastically in the past 60-plus years. While some units did begin wearing rubber gloves, coats, and boots during the war, the real push by the National Fire Protection Association to standardize safety gear for firefighters came after the end of World War II.

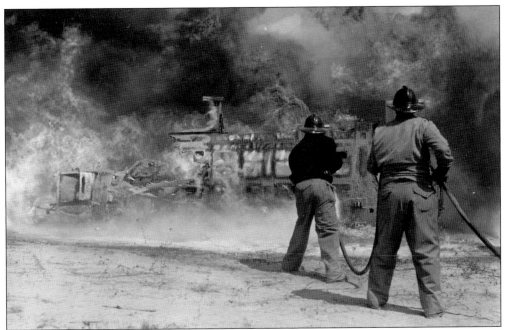

As delineated in a memo on April 19, 1944, the members of the base fire department followed a 15-step drill to keep their skills up, from raising, extending and lowering ladders to using all manners of forced-entry tools. Such proficiencies were needed when facing a blaze. Bravery carried a man far when fighting a fire on base, but trained and reinforced skills could mean life or death.

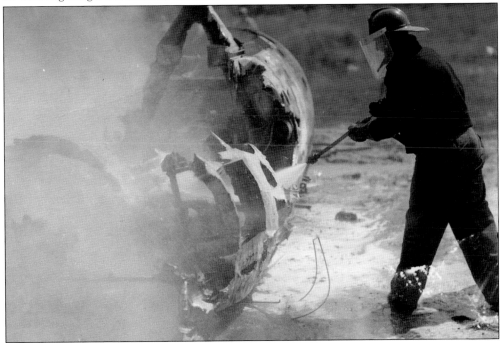

Numerous military firefighters lost their lives in action during World War II, both on stateside bases and overseas. Unfortunately for some, no training could prepare them for the horrors and dangers of fighting fires in a combat zone.

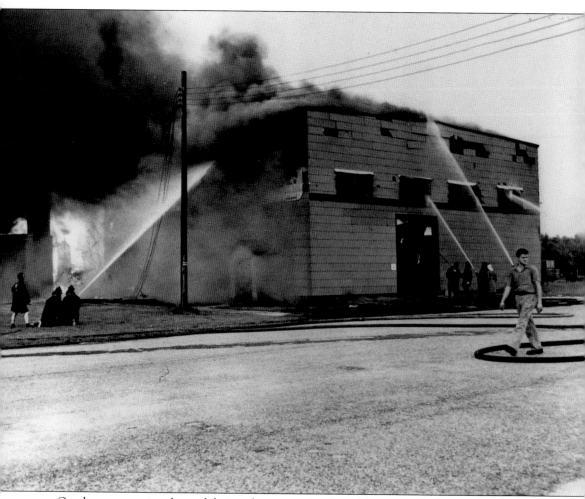

One base gymnasium burned during the war, and such problems extended beyond the war years and into the early years of the civic airport that formed on what remained of the base. Here, a commercial building burns. An all-volunteer fire company worked at the airport, comprised of men earning livings at the various businesses that sprang up around the field after the war. "When the siren sounds, members come from all corners of the airport," states an undated article written by Kay Rudderow and now on display at the Millville Army Air Field Museum, "including a radiator repairman, gunsmith, restaurant owner, and truck parts distributor." The Federal Aviation Administration relayed calls from damaged aircraft to the airfield. The article states that some of the equipment being used two decades after World War II dated back to the war but still held up its end of the firefighting bargain.

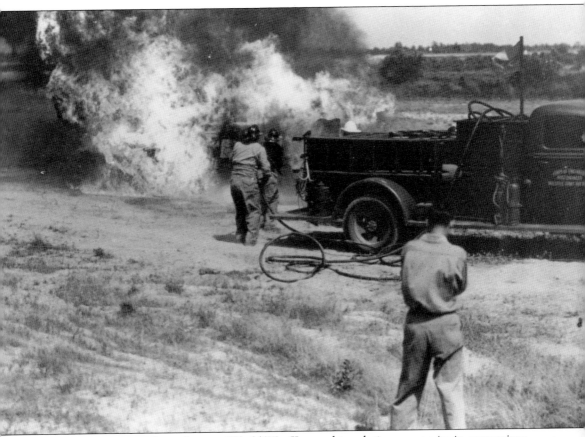

Firefighters serving in the military in World War II served in relative anonymity in comparison to the pilots over whom they watched. Early in the war, Gen. Dwight D. Eisenhower noted the amount of equipment and supplies being lost to fire in combat and called for the formation of units to travel overseas. They and their stateside counterparts were the Air Corps' "insurance policy," helping men and machines gain the opportunity to fight another day. Approximately 50 firefighters died during the war while saving countless millions of dollars in federal property and an untold number of lives. Many military firefighters went on to careers in civilian firefighting organizations, carrying the skills they learned in places like Millville to a future of saving lives in small towns and big cities.

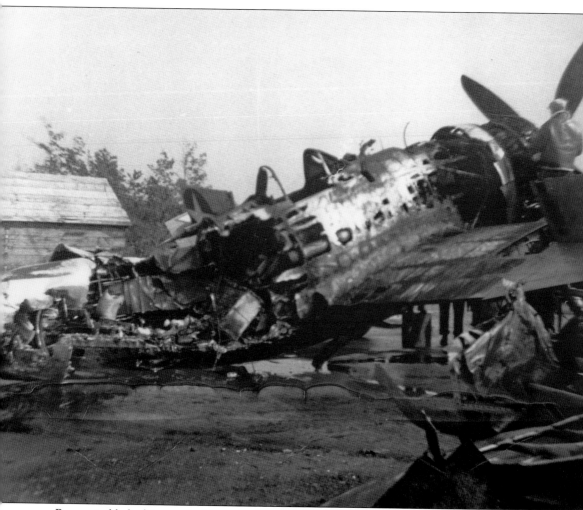

Recognizable by his standard-issue leather flight jacket, a pilot stands on the wing of a burned P-47 Thunderbolt and surveys the destruction. During World War II, more than 15,000 P-47s had been constructed in 19 types, including several unique experimental aircraft. They flew more than 546,000 combat sorties, taking out nearly 12,000 enemy aircraft and thousands more ground targets. It proved to be one of the sturdiest planes sent into combat by the Army Air Corps. About a quarter of all the planes lost by American airmen during World War II succumbed to training accidents, a ratio that did not escape the Thunderbolt. While many were complete losses, in some cases, parts could be salvaged for use in other planes still combat ready. Such salvage operations were just another facet of the working life of an army airfield.

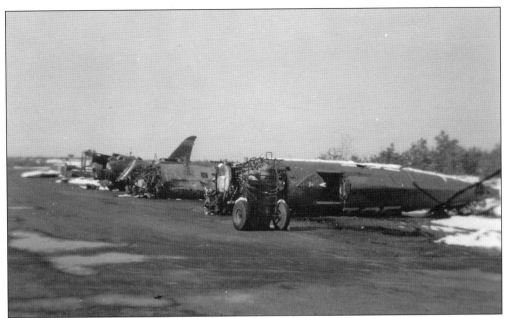

The scrap yard was one of the most depressing sites on any base. Here, at Millville, the fuselages of several irreparably damaged planes await the welder's torch. If specific parts could not be saved, then at least the scrap metal could be collected and shipped off for reuse in the war effort. It is possible that one P-47 could give up its material only to be reborn in another fighter plane months later.

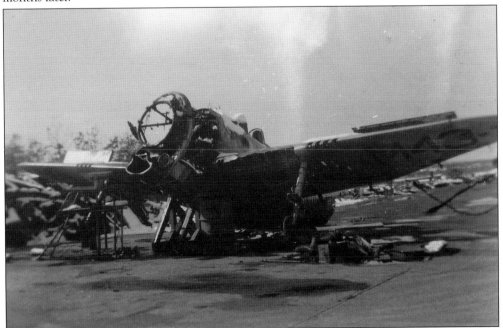

Here, snow adds to the forlorn feelings of a once-proud warbird facing the end of its existence. Each broken-up plane also carried with it the weighty notion of a dead or severely injured pilot. The Army Air Corps lost 25,844 pilots in training accidents in World War II, more than half of them in the continental United States.

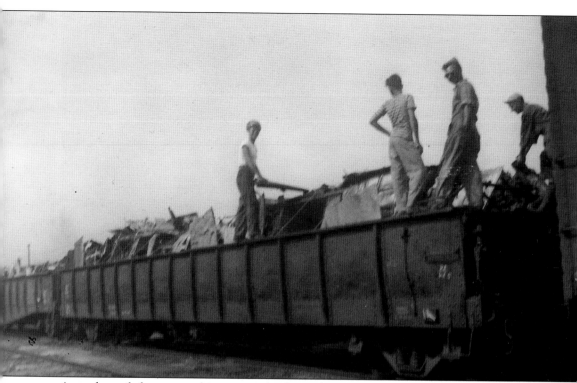

As workers piled scrap metal into cars to be shunted away on the Pennsylvania-Reading Seashore Lines railroad, they were sending away the tangible evidence of the accidents that claimed 14 lives at Millville Army Air Field during its operational days between 1942 and 1945. Some men died in midair collisions, others in solo gunnery training runs, and most in what should have been routine flights. While loss of life was inevitable, this fact did not mean that it was by any means emotionally acceptable for the men and women working on the base or living in the surrounding communities. Friends, colleagues, and sweethearts died, and for the pilots who witnessed the loss of their fellow fliers, the tragedies struck close to home. As best they could, the military men of Millville Army Air Field sought diversions from the war and its news. They were aided by many local people in these endeavors.

Four

FORGETTING THE WAR

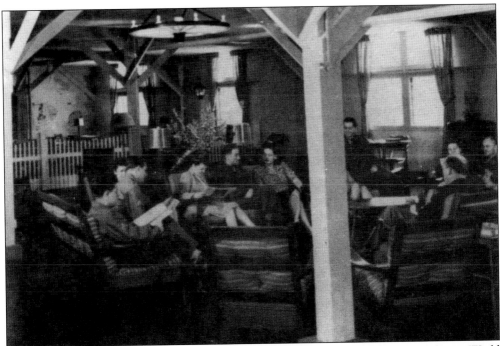

The American military rolled out innumerable posed public relations photographs during World War II. These were reassuring images that showed friends and relatives at home that their sons, fathers, and brothers were perfectly healthy and happy while training for combat. Here, in a candid image at the Millville Army Air Field, officers relax with civilian women. Downtime for American servicemen was crucial to mental health, and it could be partaken in numerous ways.

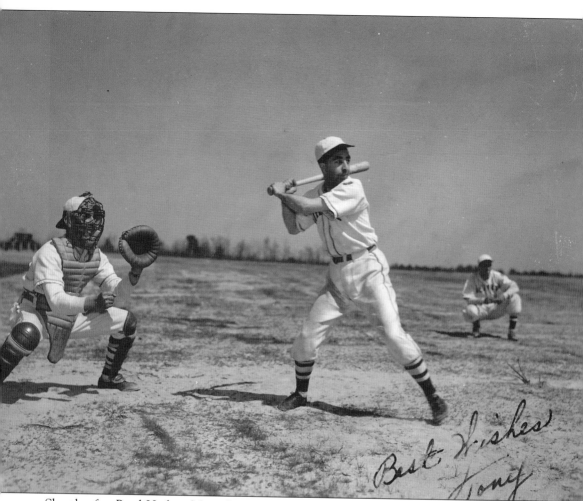

Best Wishes
Tony

Shortly after Pearl Harbor, Major League Baseball commissioner Kenesaw Mountain Landis requested Pres. Franklin Delano Roosevelt's advice for the upcoming 1942 baseball season: should it be held or not? Roosevelt stated emphatically that, yes, baseball should go on. In an age of sacrifice, there should be no reason for baseball to stop. Athletic young men serving at Millville had the opportunity to play for the base team. The Millville Flyers fielded a team of nine that included a ringer or two. Here, SSgt. Tony Correa, third baseman, takes a turn at bat. Correa was working toward a career in professional baseball before the war with a Cincinnati Reds farm team and played with the Plymouth Olympics of the Old Colony Baseball League shortly after the war in Massachusetts. During the 1945 inter-unit season, he was hitting .425 when demobilization news struck the base, derailing a baseball team that was possibly destined to be the best the First Air Force ever produced.

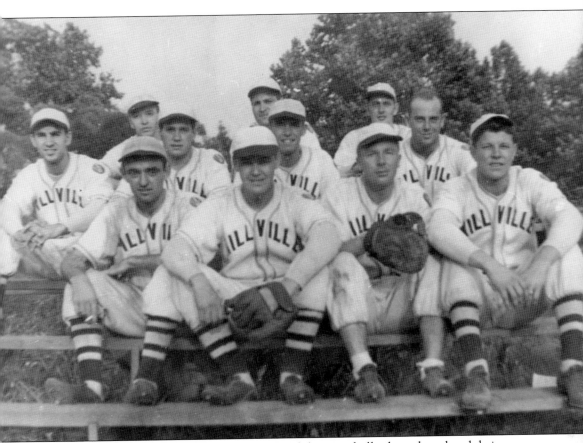

The Millville Flyers of May 1945 pose here behind the town hall, where they played their games. Correa had help from the likes of SSgt. Joseph Furgione, who played bush-league ball with a team affiliated with the Washington Senators. PFC Frank Acosta once played with a team of Puerto Rican all-stars in New York City. Player-manager Cpl. Fuzzy Scher stretched out his arm as a pitcher in the Rocky Mountain League and was grabbed by the Suffolk Army Air Base as a hurler for a swing through the western states to compete against military clubs in that region that summer. When he returned, he found that most of his men had been fitted for zoot suits. The base newspaper quipped that a passing GI had to quell Scher's disappointment by touching him on the arm and saying, "Wake up, brother, the war is over." That news, of course, also allowed the base newspaper to say, after a 12-1 drubbing by a local Coast Guard team, "It's encouraging for some of us to know that we won't have to say 'wait for next year.' "

Perhaps even more exciting than the Millville Flyers baseball squad was its winter counterpart, the basketball team. "In February and March, 1945," states the official base history, "the 'Flyers,' official post basketball team, tallied up a string of 21 consecutive wins. Almost every major service and civilian team from New York to Virginia fell victim to the Millville clan. In March, a strong Mitchel Field combination ended the winning streak for the Millville clan, and soon thereafter, the basketball season of 1945 become part of the record book." On base, teams completed for an intramural trophy, won by the Dots and Dashers of the communications department. Other athletes could join the rifle and pistol club, play tennis, or simply root for the other teams. Lack of time off to train was always a viable excuse for a team's poor showing, but the Millville teams always competed well enough to hold their heads high.

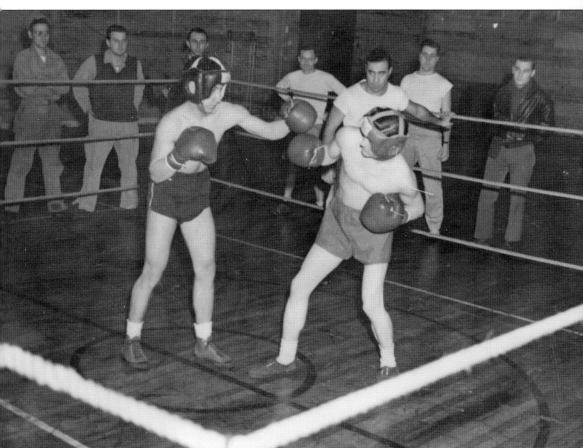

Boxing held great sway over American sports enthusiasts of the 1940s. At Millville, two leather pushers served their military time in World War II. Pvt. Joe LaSalle grew up on the streets of Brooklyn, fighting with his fists for coal for his family and food for his plate. When the opportunity presented itself, he reluctantly put on gloves and stepped into the ring, fighting at numerous venues, including Madison Square Garden. At Millville, he served as the nighttime motor pool dispatcher. PFC Herbert "Buzzie" Hanigan of West Virginia followed his father, a champion boxer of the second decade of the 20th century, into the ring without regrets. He fought title bouts numerous times, but gold always eluded him. Although he had hung up his gloves by 1945, Hanigan ran training classes at the base gym three nights a week, hoping to find the next big fighter.

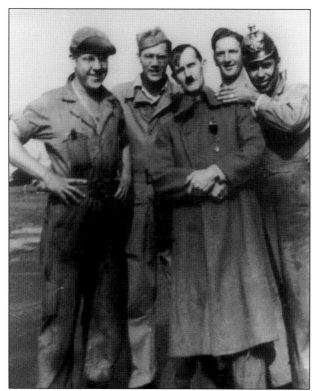

Every base, it seemed, had an Adolf Hitler impersonator. It really did not take much: a little shoe polish under the nose and a swooping comb of the hair to one side. Mocking the führer was, if nothing else, a safe way of releasing frustration with the progress of the war and a quick way to get a laugh from the other men on base.

Of course, if some men had their druthers, like this fireman from the base fire department, the führer would be met with more than just a smile when he appeared in Millville.

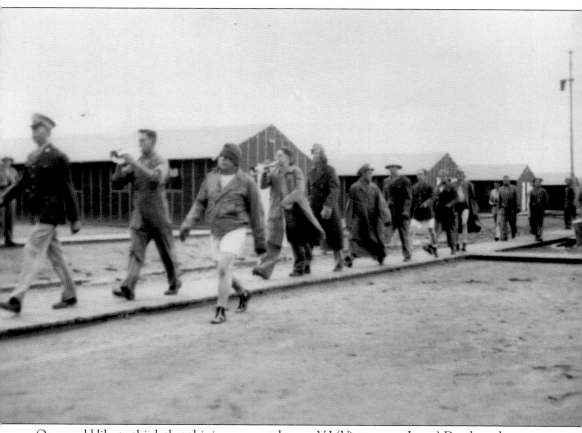

One would like to think that this image was taken on V-J (Victory over Japan) Day, but, alas, no information has come down through time with it. It would be difficult to imagine that such a breakdown in military protocol could be indicative of anything but the celebration of total victory. Aside from the obvious incongruence of a man marching out of formation in his underpants, with another man similarly clothed five steps behind, two men are blowing bugles, a third is wearing clothes for a man twice his size, while yet another one seems to be wearing a pith helmet. A release like this could do wonders to lighten the mood of many a man expecting news of death of friends and acquaintances on a daily basis. The end of the war did elicit howls of joy on base, even if it came with a new kind of stress, as thousands of soldiers began to wonder what they would do for work when they got home.

Perhaps the greatest stress relievers of all were the women who volunteered for the local United Service Organizations branch, or USO. Many men left love behind when they went to war; some found it where they served. Here, Bill and Patricia (née Vanaman) Witt share a moment at the 59th Street Bridge in Ocean City, where the USO entertained the men from the base with picnic lunches.

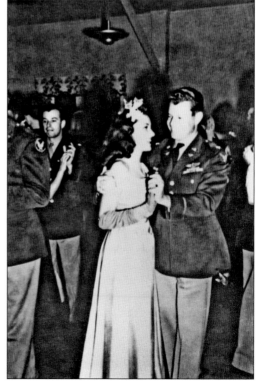

Even the base commander, Lt. Col. T.H. Watkins, got in on the act, here dancing at a function on base. USO girls were required to wear formal dresses for parties but were never allowed to wear tight clothing. In some cases, officers' wives traveled with their husbands to commands within the United States.

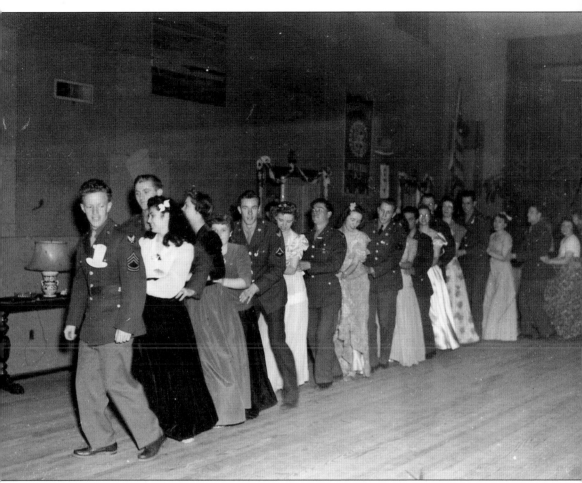

Sometimes all it took was a good conga line to get a party rocking. USO organizers in town held Saturday dances at the House of Friendship of Christ Episcopal Church, which no longer stands. When it got warmer, events were held at the old Canoe Club. Thursday nights meant dancing at the Barn. In this image, the banner of the Rotary Club of Millville hangs in the background of the House of Friendship during the 1944 Valentine's Day party as the participants dance to the sounds of the Leon Jones Orchestra. The USO took over the American Legion building at 17 East Main Street and turned it into a two-room hangout for the flyboys, who were bused in, and any local GIs home on leave. A piano, a card table, and a dance floor were all they needed to be young and free in a troubled age. A quick glimpse down the line at the faces of the young men dancing with the local girls reminds the reader that this was, indeed, a young man's war.

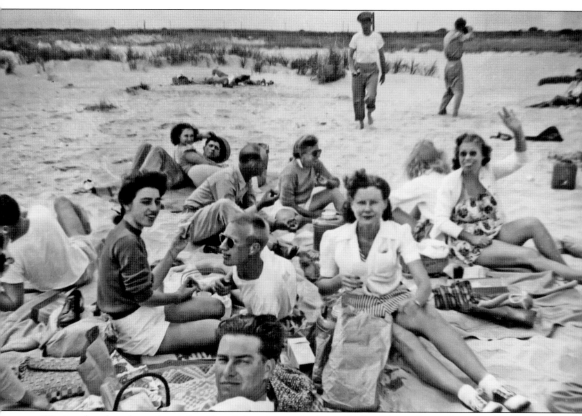

Waving her hand on the right side of the picture is Anna Belle Clunn (later Garrison). Anna Belle started as an assistant organizer of USO functions in town under the guidance of Martha Knowles, who left Millville to join her husband as he moved to a military post out of town. Anna Belle ran a tight ship, having to dismiss young women who did not complete their required 11 hours of volunteer service each week, but she was remembered fondly by all. The Millville Army Air Field Museum owns a huge file of letters sent to Anna Belle from servicemen from all over the country and the world, both during and after World War II, profusely thanking her and her team of hardworking young women for making their stay in Millville so enjoyable. Anna Belle Clunn is certainly one who completed her mission during World War II.

CAMP AND HOSPITAL COUNCIL SERVICE

Southern Jersey Camp and Hospital Council

To MISS ANNABELLE CLUNN
 CHAIRMAN OF HOSTESSES

IN APPRECIATION OF ESPECIALLY SIGNIFICANT SERVICE
GENEROUSLY GIVEN THROUGH THIS COUNCIL TO MEN
AND WOMEN OF OUR ARMED FORCES.

November, 1942 - June, 1946 *Kenneth Robb*

For Anna Belle and others like her, the thanks came from many directions, and not always from individuals. The work of the USO girls touched many layers of society.

```
            "I LOVE THOSE GIRLS DOWN IN MILLVILLE"
          (To the Tune of "I'm Just Wild About Harry")
Words by: John A. Van Sant .        Music by: (Get it from a copy)

             I love those girls down in Millville
             But they're not wild about me
             No heavenly blisses...
             In fact...no kisses
             I'm filled with misery;
             It's cold out there in Nebraska
             Without some lovin' I'll freeze
             I'll get those kisses
             I'll bring back a missus
             I may be late on m
             On my Section Eight
             But I'll be back from overseas.
```

John Van Sant sent Anne Belle not only these lyrics but also a rendition of "Give My Regards to Millville" to the tune of a familiar song about Broadway, with the words, "Remember me to High and Main / Tell all the gang down at the USO / That I'll be back again. / Whisper of how I'm missing / The good times that we all enjoyed. / Say I'll return to dear old Millville / When I'm back with the unemployed!"

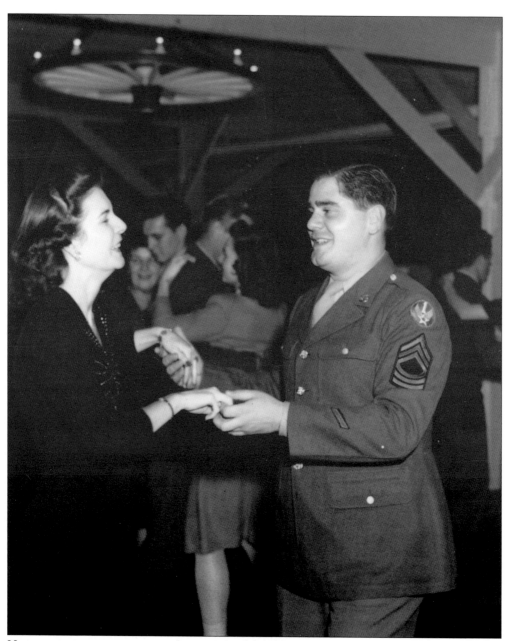

Here, a master sergeant wearing the insignia of the First Air Force dances at a Millville function. The overall concept of the USO was to provide soldiers a home away from home, a subject they did not take lightly. Approximately 1.5 million people served the USO during World War II, from local women like Anna Belle Clunn, Patsy Vanaman, Helen McClure Watson, and Mildred Sherry Sooy to top entertainers like Bob Hope, Irving Berlin, and Judy Garland. Services ranged from handing out doughnuts and simply providing an ear to chat into to fundraising on a grand scale. Thomas Dewey, the first national campaign chairman, raised $16 million before giving way to Prescott Bush, father of one future US president and grandfather of another. The federal government asked the USO to raise funds for morale and promised that the government would build recreational facilities on bases to help the cause.

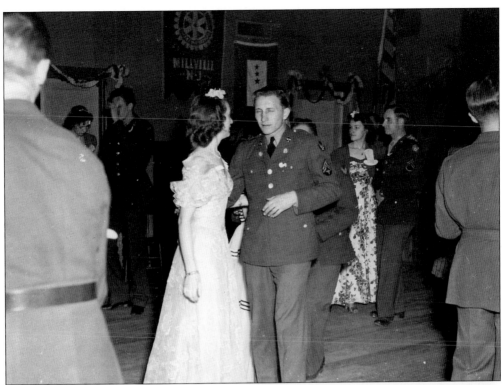

Those buildings would come to Millville, as Lt. Col. T.H. Watkins announced during his tenure that there would be a $700,000 facilities project on the base that would give the enlisted men, like this corporal blinking his eyes at the camera's flash at a USO Valentine's Day party, a servicemen's club.

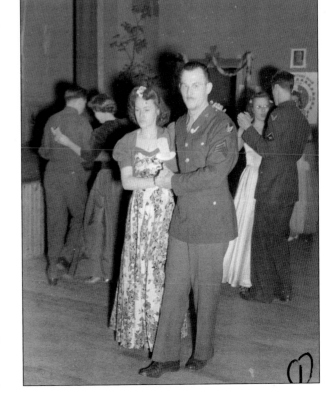

This sergeant, dancing at the same party, would have the same privileges. The project would also convert former officers' quarters to enlisted men's barracks and create a special new officers' club.

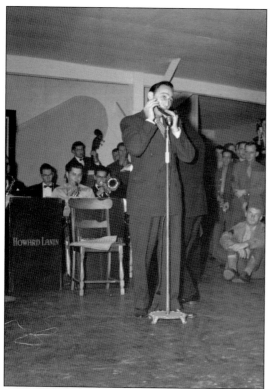

Although the Special Services Office created a base dance band, occasional performances by talents such as Howard Lanin and his Orchestra brought special moments to the troops at Millville. Lanin went by the nickname "The King of Society Music" and helped launch the career of, among others, bandleader Artie Shaw. Also, a one-night gala show featuring Donald O'Connor and his wife, Gwen Carter, made an appearance at the Base. When they left, they were given a silk parachute as a remembrance gift.

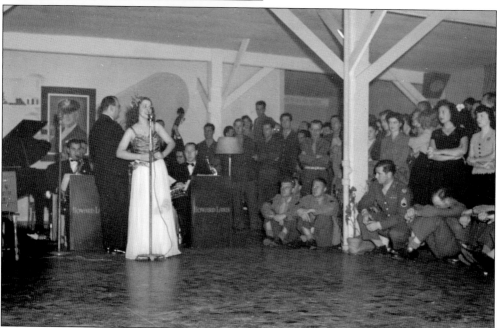

Here, at the same show, a female vocalist takes over as Lanin conducts. The new officers club opened on October 28, 1944, with the 659th Army Air Force Band, a rumba band, and the blues strains of Evelyn Knight, whose name appears on one of the original 1,500 stars of the Hollywood Walk of Fame.

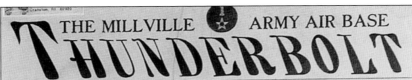

AAF Veteran Lauds Heroic Ground Forces

Transplant GI Joe from the Air Forces to the Infantry one of two conditions may develop. The soldier will either become so absorbed by the strength and striking power of the "Queen of Battle" that he will soon forget his previous allegiance, or he will hold himself aloof from the resourceful doughboys and maintain a dignified "show me" attitude. S/Sgt. R. Gessay, 24-year-old Air Force communication technician from Philadelphia, Pa., decided upon the latter attitude when he was attached to an Infantry division and returned to his former command with heaps of praise for the valor and "guts" of the slugging foot soldiers.

Landed in Africa

Landing at Port Lyautey, in Africa, in the Fall of 1942, S/Sgt. Gessay was placed on special duty with the line troops in order to coordinate communication with ground-supporting aircraft. From the hills of Tunisia, across the Mediterranean to Sicily, and into the mountainous regions of Italy, S/Sgt. Gessay followed the doughboys. He watched them ferret wily Nazis from their rocky lairs in Sicily, destroy tanks with their rocket launchers in Italy, saw them returned to field hospitals wounded and dead after being caught in the withering cross fire of an enemy stronghold. The Air Force soldier endured the rigors of battle with his front line comrades until his unit was almost annihilated when they hit a land mine in Sicily. Badly wounded, S/Sgt. Gessay was here a combat for a while and later joined the Fifth Army in Italy.

Air-Ground Fire Terrific

"Nothing is more devastating," Sgt. Gessay declared, "than the simultaneous fire power of heavy bombers dropping their eggs, the artillery joining with their salvos and the Infantry spitting flames at an enemy installation. I saw pill boxes shattered to bits, parts of mountains come tumbling down and thickly wooded areas razed when the three combat groups concentrated on a given sector." "But," he continued, "resourceful and rugged as the ground forces are, I have heard them shout and wave crazily when formations of fighters and bombers emerged from the clouds to give them support. The doughboys may kid the Air Corps GIs as "glamour boys", but they sure have plenty of respect for us when our pilots scream defiance at attack and wipe out enemy nests as though they were that many fists. "In spite of the individual effectiveness of the various arms and services," the veteran concluded, "the sure road to victory depends upon every branch of the Army conducting its campaigns with the full realization and appreciation that they are not alone in this fight."

SHORTHAND CLASS TO START

A class in Gregg Shorthand, Typing, and Military Correspondence is being initiated and will start as soon as all applications have been received and books can be obtained.

High Bond Quota Spurs Drive

"TWO ACES MAKE A GOOD PAIR"

Photo By M/Sgt. H. Henderson, MAAF Photo Section

Lt. Col. T. H. Watkins, CO of Millville Airfield, and Major Richard I. Boog, South Pacific ace, are pictured here exchanging notes during a recent visit by the noted combat pilot. Having totaled 27 Nip planes to his credit Major Bong was returned to the U. S., and is presently making a whirlwind tour of various airbase installations. Seen but not heard in the conversation is Marge, Major Bong's fiancee and constant companion during the veteran's thrill-packed aerial engagements.

Major S. G. Huey Receives Promotion

It was a silver leaf and a promotion to Lieutenant Colonel for Major Stanley G. Huey, Director of Maintenance, it was announced this week by the War Department.

A veteran fighter pilot, the Colonel was returned to the United States after distinguishing himself in combat against the Japanese during the North Pacific and Aleutian campaigns.

Born in Seattle, Wash., 26 years ago, Col. Huey attended school in his native city and was graduated from the University of Washington in 1940. Joining the Air Corps upon completion of his studies, Col. Huey received his pilot training in the West Coast Training Command and earned his wings in the latter part of 1940. He was later assigned to the Alaskan Defense theatre.

The outbreak of the war found Col. Huey patrolling the Alaskan skies in P-38s and P-40s. He received his baptism of fire shortly after the Nips attacked Dutch Harbor in the Aleutians. Having participated in numerous missions and sorties into enemy-held skies he was returned to the United States.

Assigned to MAAF in September, 1943, Col. Huey was appointed Commanding Officer of a SubGroup tactical outfit attached here. In April, 1944, he assumed the post of Base Commander and held this position until the arrival of Lt. Col. Watkins.

From his varied experience as a pilot and administrator, Lt. Col. Huey was instrumental in formulating the plans and training program for the RTU pilots here.

For meritorious service while in combat the Colonel was awarded the Distinguished Flying Cross and Air Medal.

LT. COL. S. G. HUEY

NEWS DIGEST AVAILABLE DAILY

News-hungry GIs too busy to keep abreast with the growing rumble of world events are having their appetites satisfied these days by the appearance of a daily radio and press mimeographed news digest, prepared and distributed by the Base Intelligence Office.

Compiled and edited by Capt. Orazton S. LaPorta and Cpl. James Nicholson the sheet covers up-to-the-minute developments at home and abroad in detailed form. Availing itself of radio flash bulletins the critiques of the public action are in a position to scoop metropolitan newspapers in disseminating the news at this base.

Primarily published for the purpose of soldier orientation the paper is creating an increasing interest in current affairs.

SOLDIER DIES HERE

Private Robert J. McGraw of Millville Airfield, 20, died early Tuesday morning, 20 June 1944, of natural causes at England General Hospital, Atlantic City, N. J. Present at his bedside were his parents, Mr. and Mrs. R. McGraw, of Middletown, Pa.

An Air Force Mechanic, the soldier was assigned here recently from Camp Springs, Washington, D. C.

VIGOROUS CAMPAIGN LAUNCHED

A $10,000 quota of war bond sales to military and civilian investors at Millville Army Airfield has been decided upon by the Second Service Command, it was announced today by Lt. Ralph J. Buck, Base War Loan Officer.

Although present purchases indicated an encouraging sign that the high allotment for this post may be reached Lt. Buck nevertheless, urged every officer, enlisted man and civilian to "dig down and buy until it hurt." Asserting that this drive is the "Invasion Loan," that series E bonds are the "peoples bonds," the officer renewed his plea for an all out effort to put Millville Airfield "over the top" in total sales.

Calling upon all personnel to purchase bonds in proportion to his income, Lt. Buck pointed out the facility with which certificates may be secured here. The Base Finance Office is ready to sell and issue over-the-counter bonds in denominations of $25, $50, and $100. A request at the Personnel office, Base Headquarters, for an increased or original allotment for bonds will be immediately forthcoming, he continued.

So that individual "off-post" purchases by base personnel can be credited to the soldier or civilian and included in the total computed aggregate, the Bond Officer requested that appropriate affidavits be obtained and signed at the Post Engineers, Base Quartermaster Office, Unit Headquarters, Officers' Club and Unit Supply Section.

Lt. Buck declared that no undue pressure to support the Fifth War Loan drive will be made by his office. "We rely upon the patriotism, devotion and loyalty to this nation by all not persuaded to help us reach our goal. We appeal to all members of this command to remember though, that by sacrificing unnecessary luxuries today and buying more and more war bonds instead, we are pledging our faith to the soldiers and sailors who are in the front line battles against Axis tyranny and aggression."

MAAF COMPLIMENTED

A group of ranking commercial airline representatives paid MAAF a whirlwind visit this week. After being guided by Lt. Col. T. H. Watkins through various base installations the officials expressed high admiration for the efficiency they found here.

THANK YOU

The generous contributions by the soldiers and civilians of Millville Army Airfield has made the printing of THUNDERBOLT possible. Your donations are deeply appreciated by the readers of this newspaper and we, in turn, promise to continue disseminating MAAF news honestly, fearlessly and objectively.

A major source of pride for the Millville Army Air Field, not to mention a source of news, pinup photographs and general mirth, was the biweekly publication of the base newsletter, the *Thunderbolt*. The newsletter dedicated one of its four pages to the accomplishments of the base's sportsmen, filling the other pages with general war news, profiles of men serving on the base, a letters column called "The Wailing Wall," and features such as the My Queen contest. GIs were encouraged to submit pictures of their wives and sweethearts for a beauty contest. "The newspaper made its original appearance on May 20, 1944. In its editorials, and stories, there was ever present the thought that Millville Army Air Field was to function as a base, and not as a squadron-divided installation," states the base's official history. Nearly every copy of the *Thunderbolt* is available electronically through the website of the Henry E. Wyble Historic Research Library and Education Center.

1945 The Millville Army Air Field *Thunderbolt* 1945

Sgt. Sansone

JANUARY	S	M	T	W	TH	F	S
		1	2	3	4	5	6
	7	8	9	10	11	12	13
	14	15	16	17	18	19	20
	21	22	23	24	25	26	27
	28	29	30	31			

FEBRUARY	S	M	T	W	TH	F	S
					1	2	3
	4	5	6	7	8	9	10
	11	12	13	14	15	16	17
	18	19	20	21	22	23	24
	25	26	27	28			

MARCH	S	M	T	W	TH	F	S
					1	2	3
	4	5	6	7	8	9	10
	11	12	13	14	15	16	17
	18	19	20	21	22	23	24
	25	26	27	28	29	30	31

APRIL	S	M	T	W	TH	F	S
	1	2	3	4	5	6	7
	8	9	10	11	12	13	14
	15	16	17	18	19	20	21
	22	23	24	25	26	27	28
	29	30					

MAY	S	M	T	W	TH	F	S
			1	2	3	4	5
	6	7	8	9	10	11	12
	13	14	15	16	17	18	19
	20	21	22	23	24	25	26
	27	28	29	30	31		

JUNE	S	M	T	W	TH	F	S
						1	2
	3	4	5	6	7	8	9
	10	11	12	13	14	15	16
	17	18	19	20	21	22	23
	24	25	26	27	28	29	30

JULY	S	M	T	W	TH	F	S
	1	2	3	4	5	6	7
	8	9	10	11	12	13	14
	15	16	17	18	19	20	21
	22	23	24	25	26	27	28
	29	30	31				

AUGUST	S	M	T	W	TH	F	S
				1	2	3	4
	5	6	7	8	9	10	11
	12	13	14	15	16	17	18
	19	20	21	22	23	24	25
	26	27	28	29	30	31	

SEPTEMBER	S	M	T	W	TH	F	S
							1
	2	3	4	5	6	7	8
	9	10	11	12	13	14	15
	16	17	18	19	20	21	22
	23/30	24	25	26	27	28	29

OCTOBER	S	M	T	W	TH	F	S
		1	2	3	4	5	6
	7	8	9	10	11	12	13
	14	15	16	17	18	19	20
	21	22	23	24	25	26	27
	28	29	30	31			

NOVEMBER	S	M	T	W	TH	F	S
					1	2	3
	4	5	6	7	8	9	10
	11	12	13	14	15	16	17
	18	19	20	21	22	23	24
	25	26	27	28	29	30	

DECEMBER	S	M	T	W	TH	F	S
							1
	2	3	4	5	6	7	8
	9	10	11	12	13	14	15
	16	17	18	19	20	21	22
	23/30	24/31	25	26	27	28	29

© Distributed by Copy Newspaper Service

No matter what the time of year, something was always brewing at the Millville Army Air Field from 1942 to 1945, as shown by the creative artwork of Sgt. Leonard Sansone and his popular wolf in GI clothing. It was a place that claimed lives, created heroes, and prepared men to fight, both physically and mentally. When it came down to it, two classes of men mattered most: the pilots and the men who kept their planes in working order. Without them, the Millville Army Air Field calendar might as well not even exist.

Five

THE UNSUNG HEROES

Each P-47 Thunderbolt pilot who took to the sky learned how to operate his plane, how to get the most of its turn radius, and how to perform an s-curve, or Immelman. But his knowledge of what really made the Thunderbolt one of the most effective planes to fly and fight in World War II fell second in line to that of the mechanics and armorers who spent hours working on it on the ground.

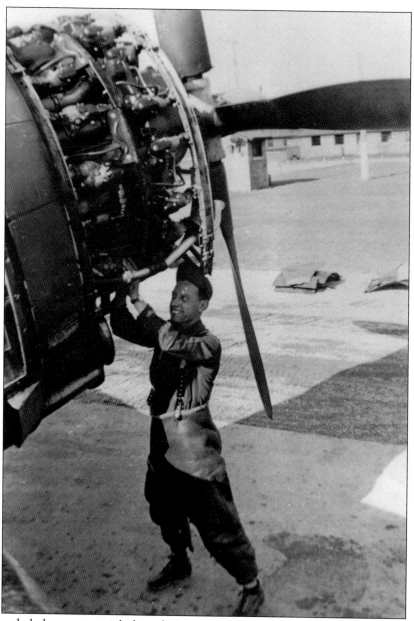

The Thunderbolt was a special plane for more reasons than one. It was powered by Pratt & Whitney's R-2800 Double Wasp 18-cylinder air-cooled engine, still known today as perhaps the most effective radial piston engine ever designed. Prior to its use in the P-47, it powered the Vought F4U Corsair and the Grumman F6F Hellcat, among other planes, and it would later be used to push the Martin B-26 Marauder medium bomber to the airspace over its targets. Originally designed to provide 2,000 horsepower in 1939, by the end of the war, R-2800 engines in use in the military were reaching 2,400 horsepower. Experimental engines reached 2,800 horsepower, absolutely remarkable output for an air-cooled engine at that time. Pilots flying the Thunderbolt could rest secure that they had more power at their disposal than most of the enemy fighter pilots across both the Atlantic and Pacific theaters of the war. Here, Ray DeStalfo poses and smiles as he works on an R-2800 engine.

One might guess, when running through photographs of the ground crews working at Millville, that there was very little work to do. That, of course, was not the case. It does seem, though, that whenever a camera was around, a mechanic or armorer was ready to ham it up, or at least provide a big smile for the photographer.

The lives of the pilots were placed in danger every day, as man attempted to "slip the surly bonds of earth," as the aviator's axiom goes. The mechanic's job was to lessen the potential for that danger by assuring the pilot that he was going into the sky with not only one of the United States' most powerful fighter engines but also one that was well-tuned.

Any good commanding officer knew that esprit de corps, or morale, was as important to the proper functioning and ultimately the survival of his unit as rigid discipline. Horsing around during downtime helped blow off steam.

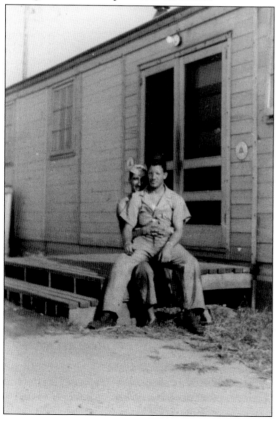

The camaraderie displayed by the Millville mechanics in photographs like the two on this page show that at least the men were comfortable working together, which went a long way toward team-building and, ultimately, victory.

Technically minded men like Reuben Wilsey, shown here, were innovators. Wilsey, born in 1920 and passing away in Craryville, New York, in 2006, donated more than 70 historic images taken at Millville in 1943 to the Millville Army Air Field Museum, including this one of himself with a pair of sand-filled practice bombs aligned with his shoulders. Perhaps he dreamed of strapping them on and launching into the air, and the fact is that if anyone could have figured out how to do it, it would have been an aviation mechanic or ordnance man. Three enlisted men arrived at Millville on January 8, 1943, to activate the ordnance department, tasked to "link, paint and store all the ammunition used for flying purposes." Painting was key. Several gunnery drills involved scorekeeping based on tracking color. Different planes were fitted with bullets painted different colors, which showed on the targets after successful hits.

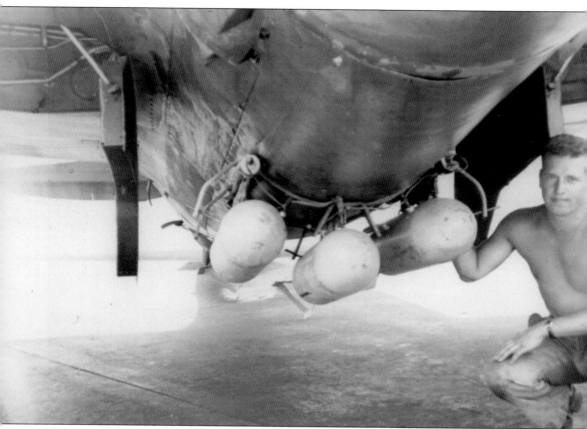

Wilsey and his mates, while always ready to pull pranks on each other, found pioneering ways to advance the evolution of warfare. "On October 4, 1944," states the base's official history, "it was learned that M/Sgt. John J. Gardner, Chief Armorer, and a returnee from the European Theatre of Operations, had invented an ingenious Rocket Machine Gun, which was submitted to the First Air Force for approval." Furthermore, as presented in this image, "Sgt. Gardner had invented an Adapter Bomb Rack which was blue printed and released throughout the Army Air Forces for use."

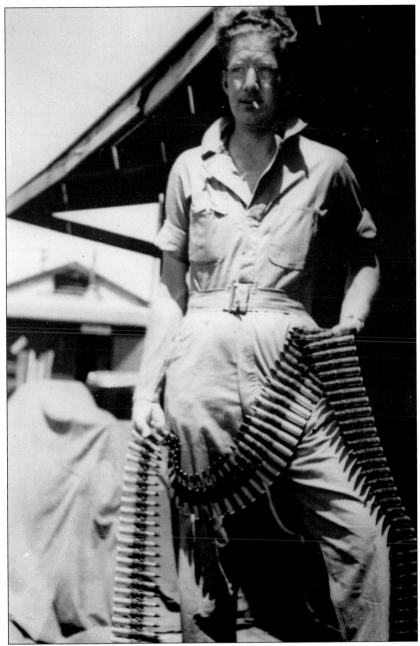

Reuben Wilsey stands here with some of the most important projectiles of World War II, the bullets of the .50 AN/M2 light-barrel aircraft Browning machine gun. Each P-47 Thunderbolt boasted eight of these guns as its fixed-mounted primary armaments. The weapon, designed by John Browning toward the end of World War I, has remained in use to the present day, only outlasted by the M1911 .45 caliber automatic pistol as the oldest small arms in American service. Each gun could fire approximately 15 rounds per second, which behooved pilots to be sure of their targets before firing. Four types of bullets were used—ball, incendiary, armor-piercing, and tracer. A typical arrangement for a single, one-second, 120-bullet burst from all eight guns consisted of 50 incendiary, 50 armor-piercing, and 20 tracer.

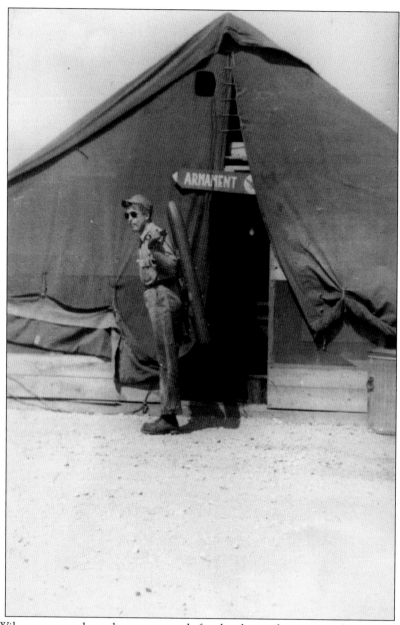

Reuben Wilsey was not the only man to reach for the sky, as demonstrated by this rocket man of Millville. The ordnance department (Detachment 2063rd Ordnance Company Aviation) at Millville grew quickly from a single warehouse and those three pioneering men to include 27 enlisted men and two officers by July 1944. "At the time of arrival at Millville Army Air Field," states the base history, "the Ordnance had 10 vehicles. Men were sent to New York's World's Fair Grounds, New Brunswick and Fort Dix to pick up vehicles. At the present time the organization is charged with 163 General Purpose Vehicles." By that time, its footprint had expanded to include five more warehouses: two for ammunition storage and one each for pyrotechnic supplies, oil and paint, and an armament shop. The eventual inclusion of triple-tube high velocity aircraft rockets (HVAR, known by the nickname "Holy Moses") transformed the P-47 from one of the best fighters of World War II to one of the most deadly fighter-bombers of the war.

Both engine mechanics and armorers relied on a heavy assortment of tools, including many sizes of wrenches and pliers, to keep P-47s in the sky. Here, a typical toolbox is presented for historical comparison to the tools used by aviation mechanics today.

By the end of World War I, the Army had graduated 5,000 aviation mechanics from its training programs. By 1941, the Army was accepting approximately 110,000 technical trainees per year, and that number rose sharply during World War II. In December 1942, 65,000 men applied for the job.

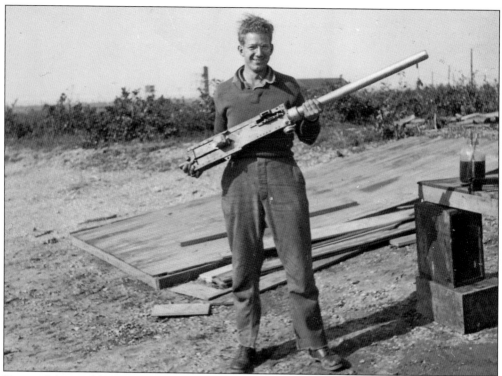

Dust and dirt could be major enemies of .50 caliber machine guns, so maintenance was important. Here, Reuben Wilsey jokingly shows the handheld capabilities of what is supposed to be a fixed-mounted gun.

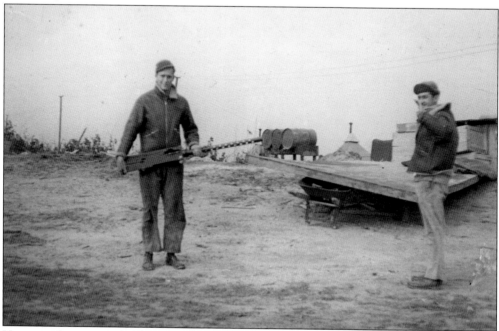

Here, another armorer holds up a colleague. There is no doubt that the gun is not loaded. While horsing around could be fun, safety ruled.

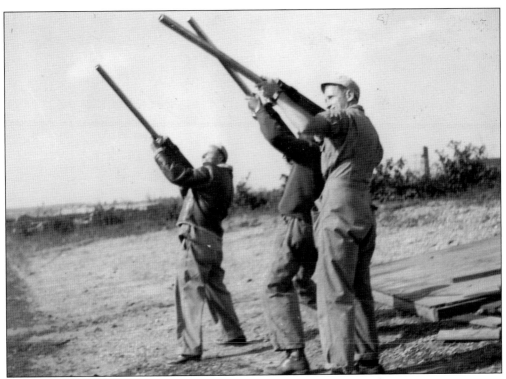

In this image, three armorers practice duck hunting in the New Jersey skies.

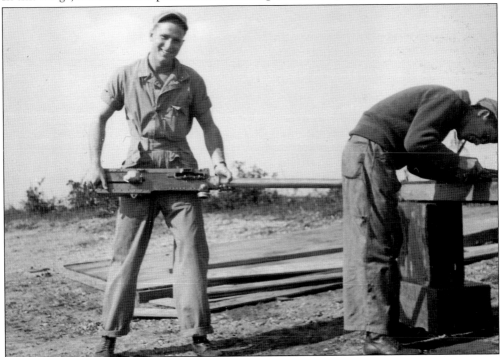

The saying "War is Hell" is attributed to Gen. William Tecumseh Sherman. If the man on the right could speak today, he might say the same.

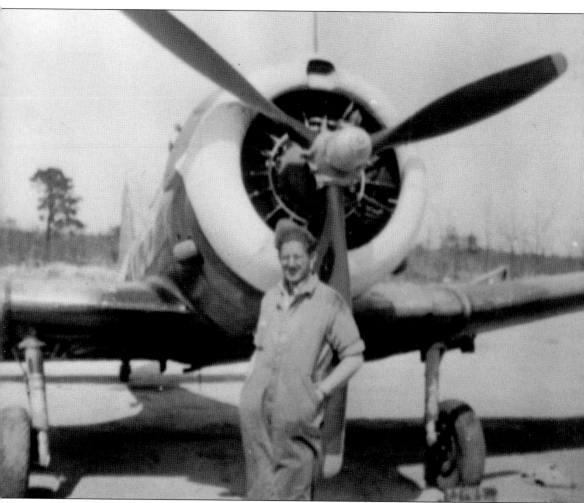

The pilots of Millville knew that men like Wilsey contributed to their successes. After winning the 1st Fighter Command's gunnery competition in December 1944, Capt. Emery A. Dietrick and Lt. John W. Hyson praised their ground crews. Said the December 9, 1944, *Thunderbolt*: "While accepting congratulations from fellow pilots and overjoyed enlisted men who had bet heavily on their home team, the winning aerial gunners took time out to heap praise on their crew chiefs and armorers. 'Sgt.Verge Nivens and Cpl. Wallace Jackson should share in whatever honors are bestowed on us,' Lt. Hyson said. 'I second that motion for Sgt. Rexroads and Cpl. Russell,' Captain Dietrick added. The competition included sixteen pilots, crews and aircraft from eight bases in the northeastern portion of the United States. The winners received the prestigious Thunderbolt Gunnery Trophy, presented by Captain Carl L. Beggs."

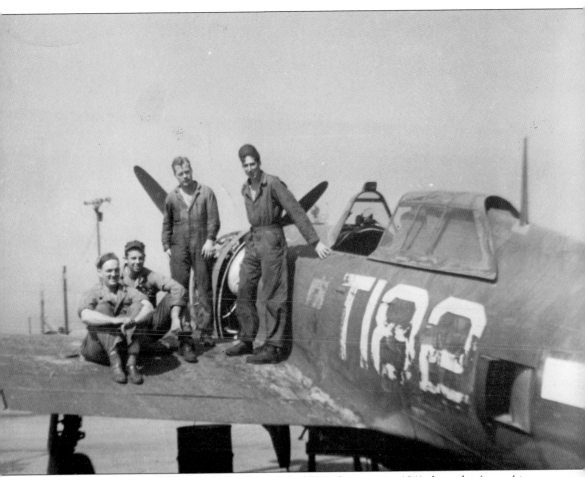

Despite the fact the Bud Abbott and Lou Costello had filmed a movie in 1941 about the Army Air Corps called *Keep 'Em Flying*, or perhaps because of it, the ground crews at Millville, like Sergeant Whitehouse, Sergeant Tuttle, Corporal Smith, and Corporal Richards, shown here in May 1944 on the wing of a trainer, wore the phrase like a badge of honor. They knew that their greatest contribution to the war effort would be to use their technical skills to keep planes and pilots in the air and therefore in combat. Behind every ace pilot stood a cadre of unsung heroes.

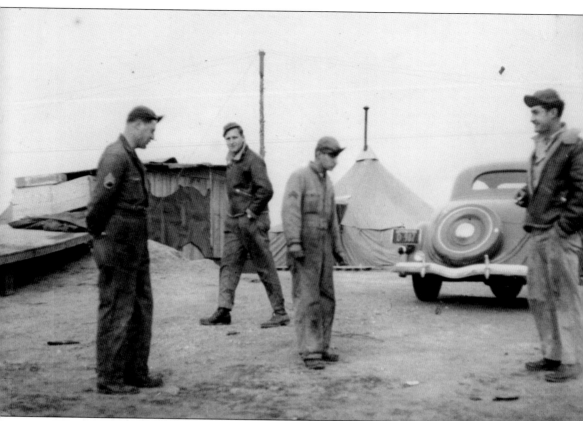

When a plane took to the air, the best that a ground crew could do was to do what the military has always done best: hurry up and wait. While they were confident that they had done their jobs, the lingering fear always remained in the backs of their minds that pilots and planes might not come home. At those times, when fear crept to the forefronts of their minds, ground crews had to remember one important fact: while they had poured their hearts and souls into the maintenance of the P-47 Thunderbolts of Millville, their counterparts in the cockpits had expended the same amount of mental and physical energy in perfecting their craft. Ninety-nine percent of the time, the return of a P-47 Thunderbolt to the airfield rested in the hands of the World War II heroes of Millville, the pilots.

Six

THE HEROES

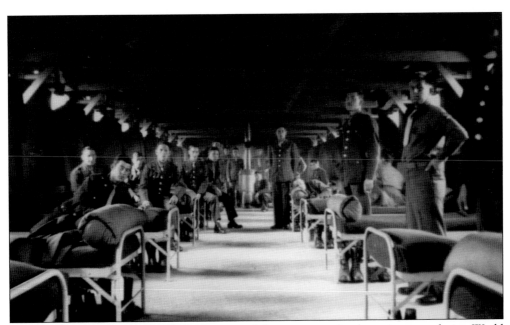

At Millville Army Air Field, 1,500 pilots passed the gunnery school requirements during World War II, yet very little is known about them. Many pilots have returned to the base years later to help build the museum that stands there now. Sometimes, when modern observers look at historic photographs of the Thunderbolt pilots of Millville, they seem to be trying to reach out through time and tell their stories.

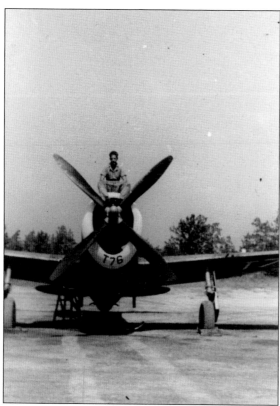

There was a lot to know at Millville and, unfortunately, a short time in which to learn it all. Pilots would rely on many people, from their ground crews and officers to returning combat veterans. But all incoming pilots knew one thing: military time would rule their lives at Millville. Here, a ground crewman waits until signaled to release his pilot and plane for gunnery training.

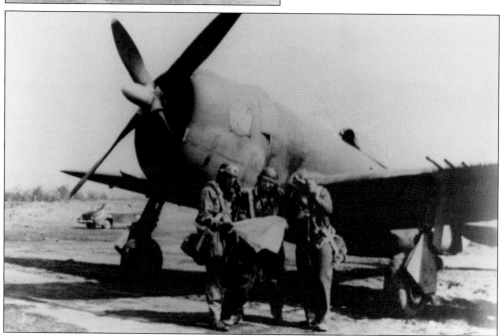

There would be maps to learn and targets to find. Especially after the taking of the Baileytown property, pilots would have to learn where to look for targets and their proper approaches. One hopes that this picture was taken of incidental head scratching before a flight.

OFFICIAL
BASE INSIGNIA

If there was one thing the men on base did know, it was that whether airman or ground crew, officer or enlisted, they had a common enemy in Millville: the mosquito. The May 26, 1945, edition of the *Thunderbolt* told the story of a mass invasion. "A cruel, vicious, disease-bearing foe has risen from nearby marshes, swamps, and stagnant waters to destroy our way of life. . . . The Office of Mosquito Information announced that MAAF intelligence were long advised of the impending assault and have taken necessary preventive measures. The Post Engineers filled in and sprayed idle waters. Waste oil was poured into critical areas." On September 1, 1945, the *Thunderbolt* announced the official adoption of the mosquito, shown here as drawn by Capt. H.L. Fogg, as the insignia of the base, to be worn on all out layers of clothing.

FIGHTER TALK

R/V: Rendezvous; assembly point. That point where airborne elements will effect a meeting.

e/a: Enemy aircraft.

Bandits: Unidentified enemy aircraft.

Bogie: Unidentified aircraft.

S/E: Single-engine aircraft; **T/E:** Twin-engine aircraft.

Big Friends: The bombers.

Circus: Large scale combined fighter and bomber operations designed with the intention of bringing enemy fighters into action.

Ramrod: Operations in which fighters escort bombers, the primary aim being to destroy the target. The fighter task is direct protection of the bombers.

Roadstead: Operations in which fighters escort bombers in attacks on ships, whether at sea or in harbor.

Rodeo: Fighter offensive sweeps over enemy territory *without* bombers.

Rhubarb: Small scale harassing operations by fighters over enemy-occupied territory against ground targets or low-flying airplanes.

Free Lance: Role of the free lance unit is to seek out and destroy enemy airplanes in an allotted area of operations, the route and height of the patrol being left to the discretion of the formation leader.

Area Support: Offensive patrol supporting bombers in designated area.

Landfall: Reaching the shoreline of the Continent. ("Landfall in" on the way to the attack; "Landfall out" on the way back to Britain.)

‹9›

Whether airman or marine, sailor or grunt, the American military man of World War II spoke his own language. Add to that fact the general 1940s slang that rang through documents like the *Thunderbolt* base newsletters, and researching the story of the base is almost like reading a foreign language vaguely related to proper English. The army knew that part of training its men to fight included teaching them to communicate, not only among themselves at stateside airfields but with pilots already in combat. This cheat sheet appeared in early training documents introducing P-47 pilots to their planes. It was vitally important, in the literal sense of the phrase, that men knew the difference between bandits, bogies, and big friends.

THINGS YOU'LL WANT TO KNOW
about the Republic P-47D Thunderbolt

CHARACTERISTICS	DATA
POWER PLANT	1 Pratt & Whitney R-2800 twin-row 18 cylinder 2000 hp radial aircooled engine. Both geared and turbine superchargers. Four-bladed Curtiss electrically controlled, or Hamilton standard, constant speed multi-position propeller.
DIMENSIONS	Span: 40′ 8″. Length: 36′ 1″. Height: 14′ 2″. Tread width: 15′ 6″.
WEIGHT	Over 13,500 lbs. (fully loaded, plus bombs or external tanks—over 16,000)
SPEED (MAX)	Approx. 420 mph.
CEILING (SERVICE)	Approx. 40,000 ft.
TACTICAL RADIUS OF ACTION	600 miles.
BOMB LOAD	1000/2000 lbs. (as short-range fighter bomber)
ARMAMENT	8 x .50 cal. guns in wings.
PROTECTION	Front and rear armor protection for pilot. Leakproof tanks, bullet-proof glass.
CONSTRUCTION	Low wing, single place, all metal monoplane, single tail. Oval shaped fuselage and elliptical wing are characteristic.
REMARKS	Manufactured by Republic. A number of P-47 G's were built by Curtiss.
	Latest models of D series with water-injection engines, improved super-chargers and wide-blade propellers have higher top-speed, better rate of climb and maneuverability.

"A Thunderbolt is a destructive flash of lightning . . . to be accompanied by the fall of a solid body. A Thunderbolt is a dreadful threat."
—NOAH WEBSTER

OFFICE OF THE A. C. OF S., A-2, 1 FIGHTER COMMAND, MITCHEL FIELD, N. Y.

« 2 »

There were, of course, other important facts to know about the P-47 other than the jargon that came with it. A prospective pilot flipping open the introductory manual for the first time would have been happy to see certain statistics. Eight .50 caliber machine guns packed one heck of a wallop. Maximum speed was 420 miles per hour. The fastest car in the world in 1938—ironically called "Thunderbolt"—had achieved 357 miles per hour, but the Delahaye 135 convertible, the ultimate prewar luxury car, could only hit 95. No young man coming out of high school could fathom what it felt like to reach 420 miles per hour. The plane's maximum altitude was 40,000 feet. The Empire State Building, the tallest building in the world then, stood at 1,250 feet. The ideas of being 40,000 feet in the sky or traveling 600 miles and back in a single day must have seemed unimaginable.

To aid the pilots in their gunnery practice runs, the base developed a series of wooden mock targets built specifically to be shot up. Mock-ups like this fake tank in a Millville farm field were direct results of a low-level bombing study conducted in Florida by Gen. Grandison Gardner, according to Hal Borland in the November 1944 edition of *Popular Science*. Other mock targets included a train, submarine, aircraft carrier, ammo dumps, and marching troops.

Of Gardner, Borland said, "He and Col. Sargent Huff, of Ordnance went to work looking primarily for a way to bomb tanks effectively," at the Army Air Forces Proving Ground Command. "They had the pilots, the planes and the bombs—and it wasn't long before they had a technique."

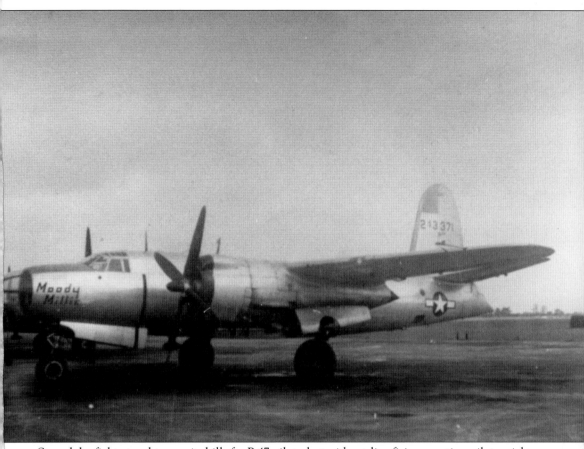

Staged dogfights taught pursuit skills for P-47 pilots, but without live firing practice, pilots might never be ready to fire their guns "in anger." Enter the towed target operators. The volunteer pilots and crews of the B-26 Marauders that flew over Millville served for one purpose: to fly a target 1,200 feet behind their planes on a cable specifically designed to be shot at in aerial gunnery practice. *Moody Millie*, shown here, was a towed target aircraft that served at Millville. After a practice cycle concluded, or if the banner were shot off or too damaged to be of any more good, the plane would descend and jettison the cable at a predetermined drop site, then go in for a landing. Pilots' .50 caliber bullets would have been painted red, blue, or black or left in their original state, and scores could be tabulated by looking for the color streaks on the target.

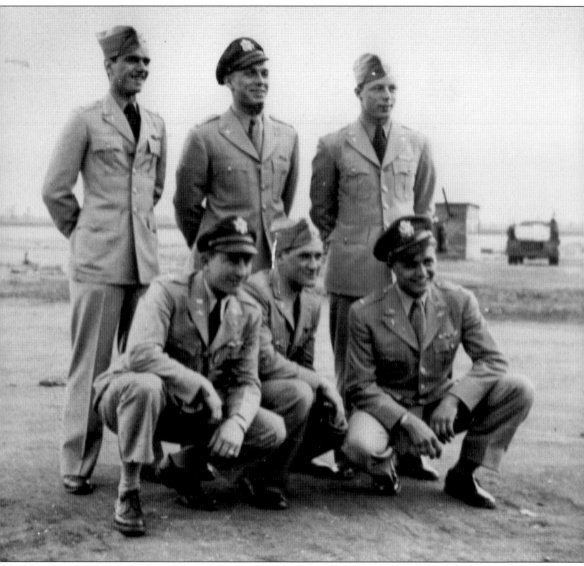

Here, a group of officers from the 352nd Fighter Squadron of the 353rd Fighter Group poses at Millville. The squadron formed on September 28, 1942, at Mitchel Field in New York and was activated three days later. The men of the 352nd flew P-47s into combat in Europe, supporting long-range bombers, strafing, dive-bombing, and otherwise contributing to the overall assault on the Third Reich. The unit fought at St. Lo, helping to effect the break through enemy lines there, but by the time it fought at the Battle of the Bulge, it had converted to the North American P-51 Mustang. Pictures like this one remind one and all that for young men in the military in World War II, time had to be treasured.

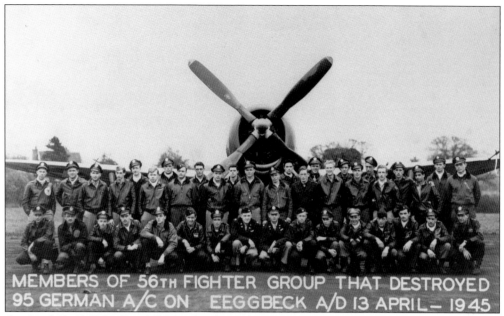

MEMBERS OF 56TH FIGHTER GROUP THAT DESTROYED
95 GERMAN A/C ON EEGGBECK A/D 13 APRIL— 1945

On April 13, 1945, Lt. Randall Murphy claimed 10 German airplanes as ground strafing victims, the greatest single mission count during the war, but just a portion of the 95 that the 56th Fighter Group took out that day. Gunnery training at bases like Millville directly led to these victories.

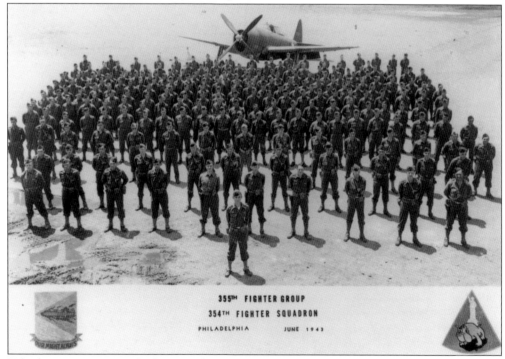

355TH FIGHTER GROUP
354TH FIGHTER SQUADRON

PHILADELPHIA JUNE 1943

Whether operating as a freelancer, taking out targets of opportunity in a given area, or directly supporting bombers in a tight formation, the men of a particular squadron had to operate as a unit. Among the many things learned at Millville was pride in one's unit, one's country, and one's skills.

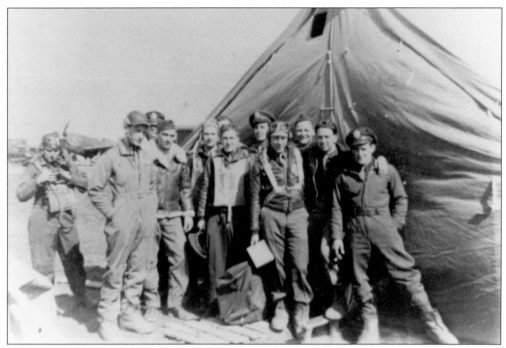

The men of the 59th Fighter Squadron knew when they arrived at Millville in 1942 what the units that followed would come to know as well. They had a common purpose, and the more they stuck together, the better the chance was that they would all come out of the war alive.

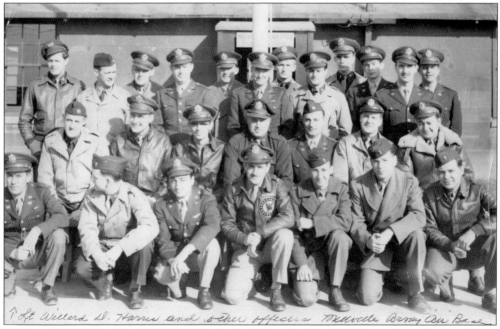

On June 28, 1943, 2nd Lt. Willard D. Harris (far left) arrived at Millville, and nearly a year later, he was in charge of the engineering section of the Office of the Post Engineers. He, and the other, unidentified officers pictured here, watched many a pilot hone his skills and vanish into the sky on the way to war.

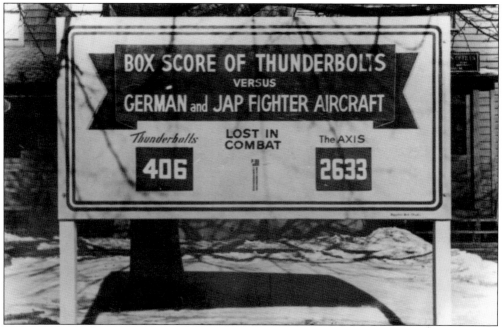

Many American boys knew one thing above all others: how to read a box score. Whether it was Red Sox vs. Yankees, Chicago Bears vs. New York Giants, or P-47s vs. the Axis, pilots understood the score. While the odds looked good at 6-to-1, in fact, the words "lost in combat" still held a lot of power.

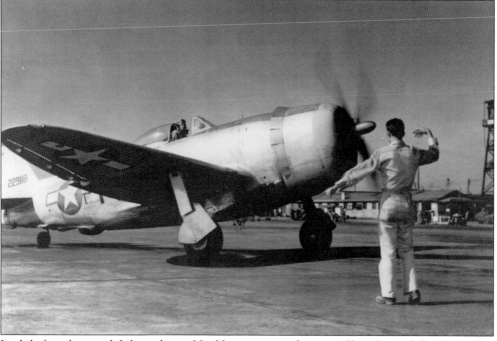

Luckily for pilots, so did their planes. Unable to see over the nose of his plane while taxiing, this pilot follows the directions of a ground crewman. Advice was everywhere on base, including in the voices of returning combat veterans.

Maj. Richard I. Bong, shown here at right, roared into Millville in June 1944 on a war bond drive. By the time of his arrival, in a Lockheed P-38 Lightning, Bong had shot down 27 enemy planes on his way to a total of 40. Greeted here by commanding officer Lt. Col. T.H. Watkins, Bong immediately became an inspiration to the young men training at Millville. Bong left quickly, continuing his extensive tour of air facilities on the East Coast, and then returned to combat. By the end of the war, he was the United States' "Ace of Aces." Technically an instructor, Bong continued to fly combat missions whenever he could, unsatisfied with his own gunnery standards. On several occasions, he flew directly through the wreckage of his victims' planes, having approached so close to them for fear of missing them with his guns. Released from service in January 1945, Bong returned home, married his sweetheart, Marge, and helped promote the war effort. Sadly, he passed away in 1945 in an experimental jet, the Lockheed P-80 Shooting Star.

Lt. Richard H. Mushlit, shown here, twice won the coveted Silverman Trophy for gunnery, donated by merchant Adolph Silverman of Vineland in late 1944. Mushlit took the honors in both March and May 1945.

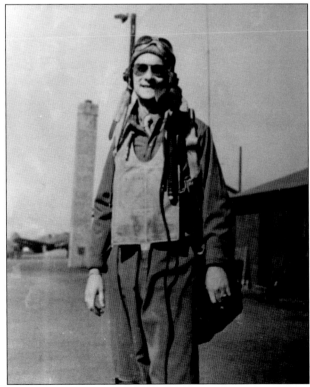

Lt. Bill Reynolds here models the standard flight gear of the P-47 pilot. The air at 40,000 feet could get cold, so goggles were a welcome commodity. The inflatable vest on his chest was known colloquially by pilots as the "Mae West."

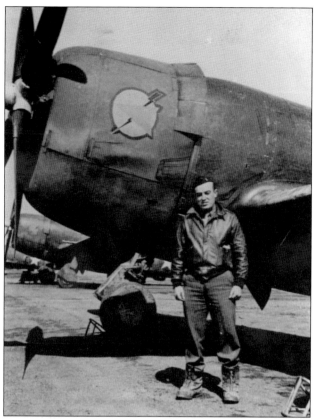

Some photographs descend through time with conundrums attached. Three pilots named Murphy—two named John and one George—flew out of Millville during the war, one for an OTU (overseas training unit) and two for RTUs (replacement training units). With that said, here is a Murphy at Millville.

FO E.O. Perry never found his way home. He disappeared during a flight in England with the 352nd Fighter Group, known as the "Blue-nosed Bastards of Bodney," one of the most decorated gatherings of pilots fighting the war.

Here, 2nd Lt. William McCutcheon Hartshorn pauses to look back as he steps into the cockpit. A graduate of Woodrow Wilson High School in Washington, DC, and matriculating at Dartmouth College when the war broke out, Hartshorn answered the call in October 1942 by signing up with the Army Air Corps. This moment in time, in 1944, as he trained at Millville with the 61st Squadron, 56th Fighter Group, caught Hartshorn on his way to a solid war record. He flew 26 missions in his P-47 before being shot down over Holland with nearly half his squadron, breaking his leg during the landing. He spent the next two years in military hospitals in Europe and back home in the United States, receiving the Purple Heart and the Air Medal. Hartshorn finished his degree at Dartmouth in 1948 and spent much of his downtime making model planes for the rest of his life.

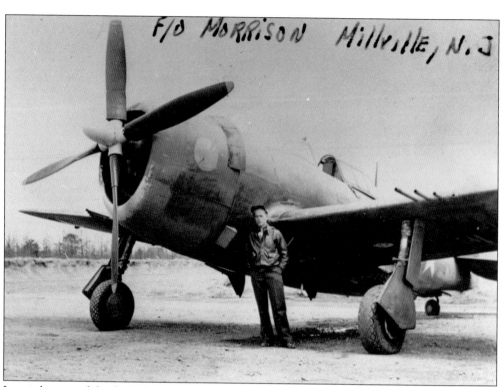

Less is known of the fate of FO George W. Morrison, who flew as a replacement trainee late in the war.

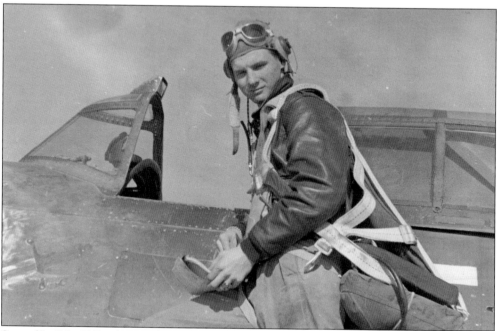

Second Lt. John E. Brink arrived at Orbetello Airfield in Tuscany, a former Luftwaffe airfield captured by the Americans, on July 1, 1944, with 23 other pilots from the 525th Squadron, 86th Fighter-Bomber Group, and quickly became "the hottest of the hot" pilots in the European theater.

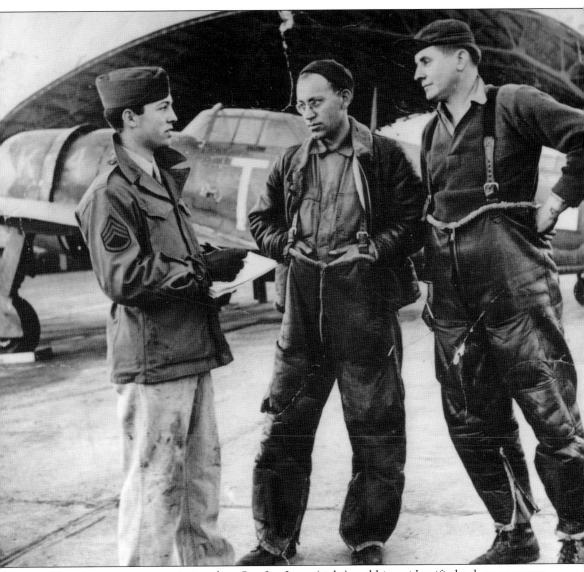

If staying warm was a priority, then Sgt. Joe Laux (right) and his unidentified cohort at center have the answer: AN-T-35 winter flight pants. In an age before Gore-Tex, the best combination the makers of these pants—like the Poughkeepsie Leather Coat Company or the AeroLeather Clothing Company of Beacon, New York—could come up with was leather on the outside and sheepskin on the inside. A pair of suspenders kept everything in place. When coupled with a standard issue leather flight jacket, the pants contrived to keep a pilot warm in the cold climes of the upper reaches of the atmosphere. The third man in the photograph is unidentified as well.

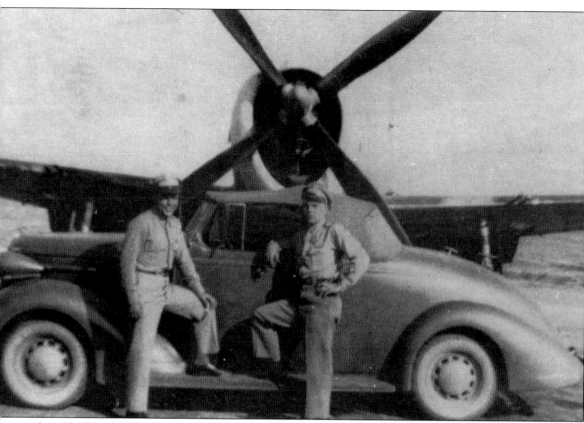

Jean K. "Woody" Woodward and Jay "Herky" Thomson had a lot in common. They both trained at Millville, and they dated sisters, eventually marrying them. Here they showcase the car they used to rendezvous with them off base. Woody served with the Air Force for 32 years, flying 105 missions in England during World War II, 117 missions in Korea, and 47 more in Vietnam before retiring as director of Reconnaissance and Electronic Warfare at the Pentagon. "Woody destroyed five P-47s, either by crash landing the plane or bringing it back so badly shot up that it could not be salvaged," says a recent article in the Millville Army Air Field Museum newsletter. Herky was not so lucky, shot down by a Focke-Wulf 190 over France on July 14, 1944. Both men were uncles of Jim Vertolli, past president of the Millville Army Air Field Museum.

Second Lt. John H. Slinde left Millville to fly in Europe, joining the Hell Hawks of the 365th Fighter Group. On December 17, 1944, then-captain John H. Slinde led a flight of 13 P-47s in support of infantry troops on the second day of the Battle of the Bulge. His flight pounced on an unsuspecting and backed-up column of German men and equipment, strafing and dropping bombs.

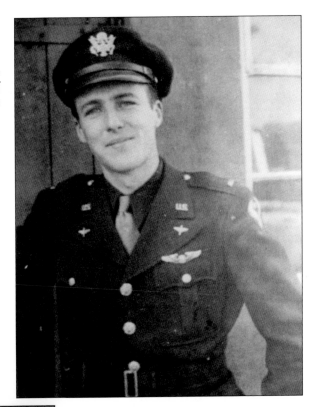

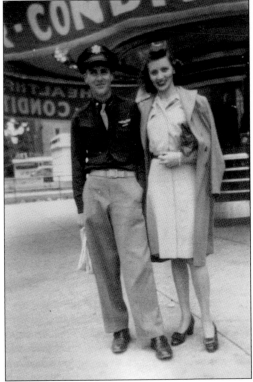

In a lighter and more peaceful moment, Slinde was captured outside the Vineland Landes Theater with his best girl. Fliers from Millville could often be seen at watering holes in Vineland like the Circle Restaurant and Bar and the White Sparrow Inn, which they affectionately dubbed "The Dirty Bird."

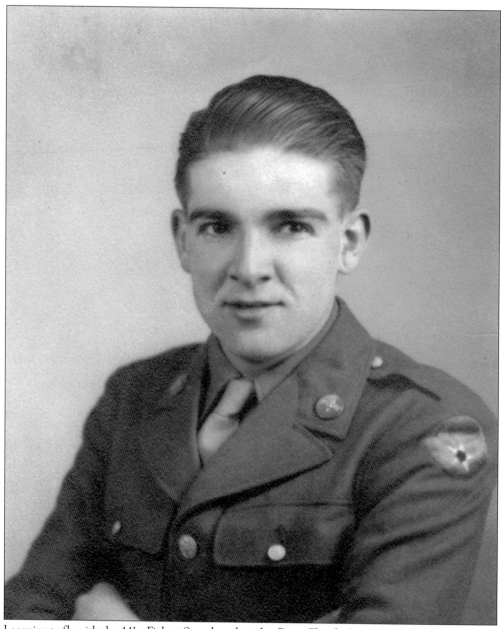

Learning to fly with the 441st Fighter Squadron, based in Perry, Florida, James R. McGeachy represents both the youth and the inherent confidence of the American fighter pilot in World War II.

Bill Rich taught aerial gunnery before packing his bags for Europe, where he flew P-47s with the 56th Fighter Group alongside the famous Frances "Gabby" Gabreski. Back home, long after the war, Rich served as the chairman of the Millville Army Air Field Museum, keeping alive all the memories of the men who served at the base.

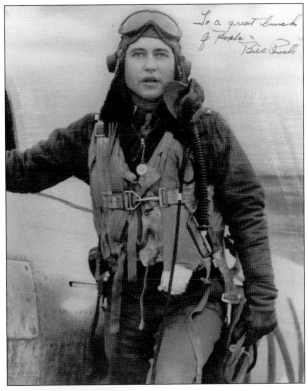

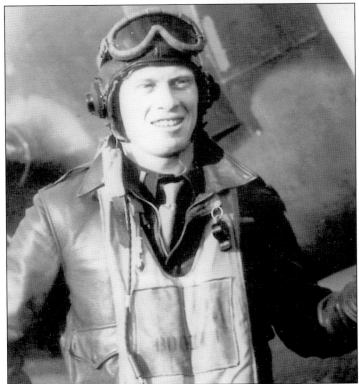

Bernie Borelli flew 99 missions in Europe with the 360th Fighter Squadron, 356th Fighter Group, leaving behind his family's barbershop to grab hold of the stick of a P-47. His vision propelled the formation and direction of the Millville Army Air Field Museum, and he added a real-life touch to the World War II stories he told schoolchildren touring the museum.

While proudly supporting the men who had traveled from all around the United States to train in Millville, the local populace had many more reasons of which to be proud. Sixty-one men from Millville died in World War II service, though some of those men moved to Millville after marrying local girls while serving at the base. In all, Millville sent 2,200 men and women into service, including Marty Garton. Marty was born in Millville, living on Buck Street and excelling as a football and basketball star at Millville High School. He followed his studies there by enrolling at Hines Junior College in Raymond, Mississippi, and then at Mississippi Southern College at Hattiesburg. It was there that he met the love of his life, Prudie. In 1942, he joined the Army Air Corps to fly and fight for his country. He joined the 512 Fighter Squadron, 406th Fighter Group, and headed overseas.

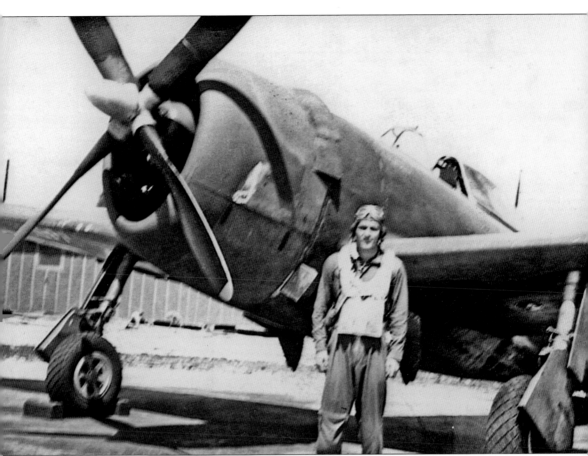

Around 10:30 a.m. on September 27, 1944, trouble developed with Marty's P-47. On an armed reconnaissance flight over Saarbrucken, Germany, about seven miles southwest of the city, he lost control of his plane, which dove and crashed, a tragic sight witnessed by several members of his flight. Just 23 years old, Marty was listed as missing in action, later confirmed dead. His death came one day after the birth of his son, Marty Jr. Initially buried in the US Military Cemetery at Hamm, Luxembourg, Marty's remains were reinterred in the veterans' memorial plot at the Mount Pleasant Cemetery in Millville in 1949. Years later, the town of Millville would make its respect and love for its lost soldiers, sailors, and airmen known through the visage of Marty Garton, who still looks over the townsfolk from the side of the town hall.

No matter what their role was in World War II—flier, radioman, armorer, mechanic, or one of dozens of other jobs, servicemen like Art Eastwood breathed life into the Millville Army Air Field in the 1940s. Art, a US Army Air Corps staff sergeant, served as a radioman at Millville. He was part of the Army Airways Communication System (AACS), which was the Army's version of the FAA.

Art, who married a local girl, Evalyn Shaw, made Millville his home and has helped build the museum that stands today. As they did in the 1940s, the returning veterans who visit the site of the Millville Army Air Field again bring life and vitality to one of America's special places. Without their help, the museum would not be nearly the memorial that it is today.

Seven

REMEMBERING THEM ALL

The story of the Millville Army Air Field ended abruptly in the fall of 1945, and the once-thriving base suddenly became a ghost town. Buildings were moved, some used for veterans housing, and a municipal airport—the original intention of the Millville Flying Club—came to be. To say the founders of the Millville Army Air Field Museum had a tall task ahead of them when they sought to set up exhibits in the old headquarters building would be a massive understatement.

And it was a massive undertaking, but thanks to the sweat and toil of hundreds of volunteers over the past three decades, the museum now thrives, a proud and fitting memorial to the men and women who served at the Millville Army Air Field.

Starting with founder Michael Stowe's gathering of artifacts, primarily found in the woods that once served as part of the gunnery ranges for the base, the exhibits have grown steadily. In 1983, Stowe approached city officials to request a permanent home for a museum dedicated to the story of the P-47 pilots of Millville. Stowe soon met Andy Kondrach, a P-47, warbird, and aviation enthusiast who helped organize and found the Millvlle Army Air Field Museum in 1987.

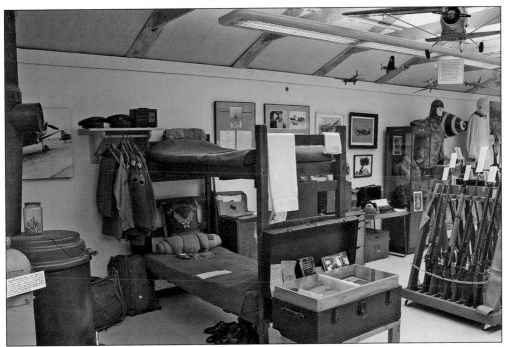

Exhibits cover all aspects of military aviation as well as other facets of the World War II story. Visitors turn one corner and are face-to-face with the Tuskegee Airmen. Turn another, and they are suddenly in a representation of living quarters as they appeared on base in 1943 (shown here).

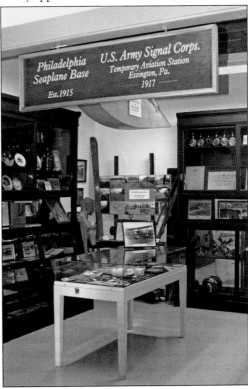

The museum has expanded to include other collections as well. Here stands the exhibit of the Philadelphia Seaplane Base Museum, a related story that became part of the Millville Army Air Field Museum in 2000. The base has been in operation since 1915, when a Philadelphia banker bought a Curtiss flying boat and opened a flying school.

The mission of the museum is to educate, and there is no better way to do so than through interpretation of personal experiences. Schoolchildren, here listening to the stories of World War II veteran Andy Hunter, who served in the military during those dark days, are enraptured by tales of dogfights, parachuting, avoiding capture, and living to fight again.

The museum reaches beyond the basics of tours and lectures to include students in the gathering of oral histories. These remembrances shared by veterans are sent from the museum to the Library of Congress to become part of the official Veterans History Project. Pictured here, a high school student interviews a US Army World War II veteran who served in the OSS, where he used his knowledge of six languages to gain information behind enemy lines and report back troop movements and other valuable information.

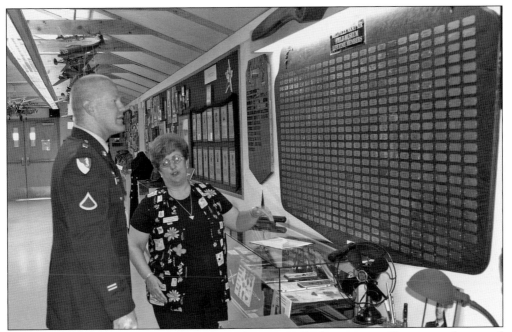

The museum displays a "life member" plaque, listing on which is open to all veterans who served at the Millville Army Air Field during its operational years. Here, PFC Erik Stenberg, US Army, proudly finds the name of his grandfather Capt. Bill Rich, a former P-47 pilot who served at the base, with the help of the museum's executive director, Lisa Jester.

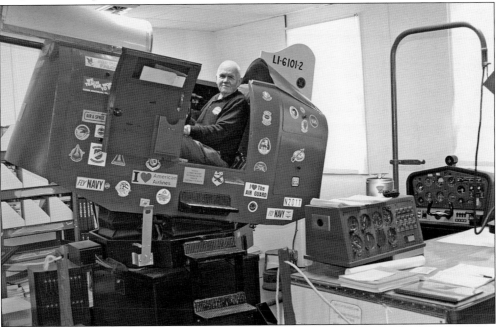

On special occasions, visitors are privileged to step into a Link Trainer flight simulator, one of just five fully operational machines of its type in the world today. It is on display in the original World War II Link Trainer building in the museum's historic complex. Here, volunteer Ron Frantz tests his skills at night flying.

Students are sometimes selected for special duties. During Veterans Appreciation Days held at the museum, they are given the opportunity to put on historical uniforms, including World War II pilots' flight suits.

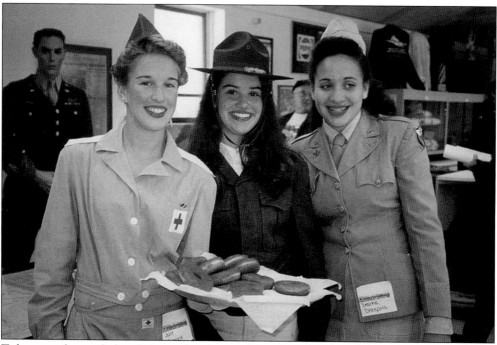

To better understand what their grandmothers and great-grandmothers did to support the war effort, young women are extended the same opportunities to serve in the roles that women did in World War II. Here, three students play the role of Donut Dollies during a Veterans Appreciation Day.

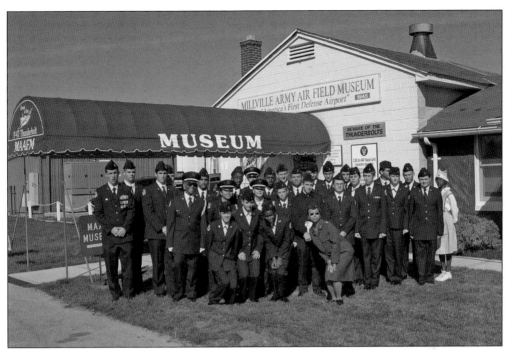

Here, during the 2007 Veterans Appreciation Day, members of the Williamstown Junior Reserve Officers' Training Corps (JROTC) pose for a picture.

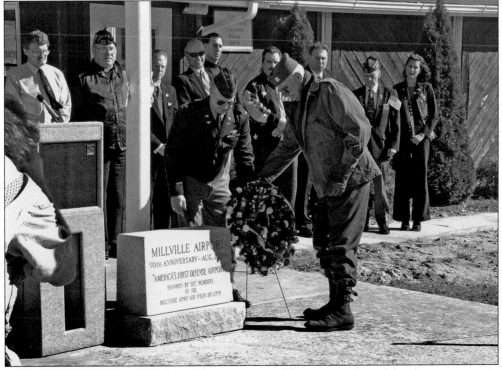

Veterans Appreciation Days are always solemn occasions. The museum, through local veterans, pays its respects not only to the men who flew from Millville but to all veterans of all American wars.

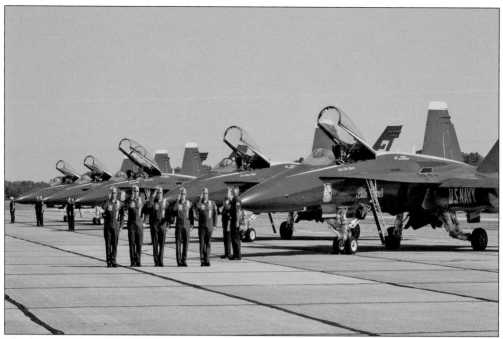

The beauty of having a military aviation museum at an active municipal airport, especially one large enough to allow jets to land, is the potential for spectacle. Here, the US Navy's Blue Angels pilots salute while their ground crews stand at attention in front of their F/A-18 Hornets.

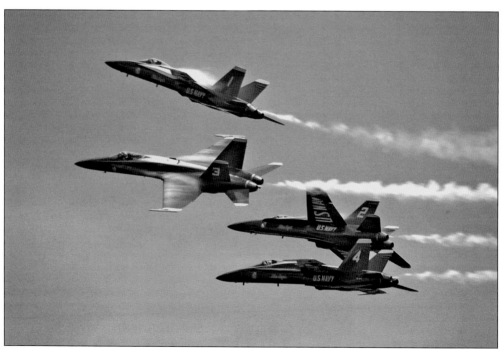

Since 1946, the Blue Angels have performed, in various planes, in front of more than 450 million people, including hundreds of thousands at Millville. Despite the difference in branch of service, the Blue Angels pilots share the ethic of national military service with the P-47 pilots of yesteryear.

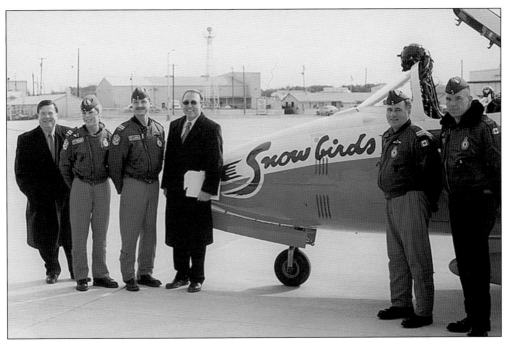

The airport also plays host to other performing units, like Canada's Snowbird Demonstration Team. The Snowbirds have performed at two of the Millville Army Air Force Museum's Millville Air Shows.

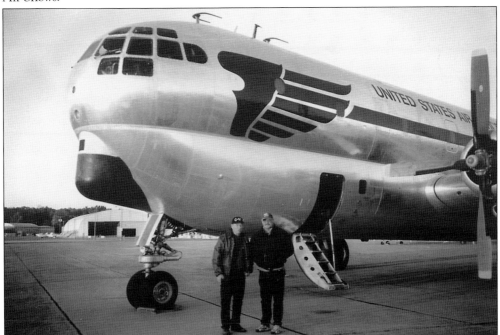

Rare aircraft visit Millville Airport and are often hosted by the Millville Army Air Field Museum. This Boeing C-97 Deliverance, owned by the Berlin Aircraft Historical Foundation, spent several months on the ramp while grounded with an engine problem. It is believed to be the largest plane ever to land at Millville and is one of only two flying in the United States.

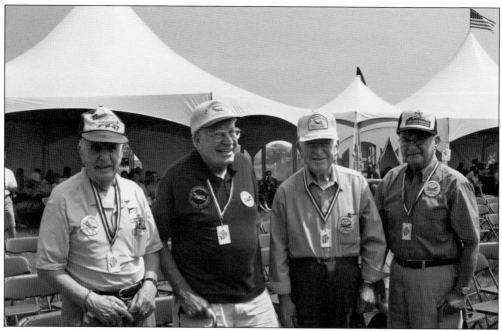

Here, visiting P-47 Thunderbolt pilots enjoyed the Millville Wheels & Wings Airshow 2007 from front-row seats in the VIP area. Recognized and honored during opening ceremonies, they are, from left to right, William F. Desante from Fair Haven, New Jersey; Roland R. Weeks from Tipp City, Ohio; Maurice C. Pimm from Birmingham, Alabama; and Ries Daniel from Pikesville, Maryland.

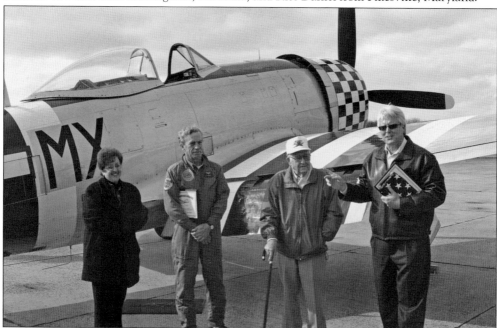

An original World War II P-47 Thunderbolt fighter plane, *No Guts, No Glory*, one of just nine flying in the world today, is at home at Millville Airport. Warbird collector Tom Duffy (right) purchased the plane in 2007, and it is welcomed here by Lisa Jester (left), museum executive director, and Bill Rich (third from left), a World War II P-47 pilot.

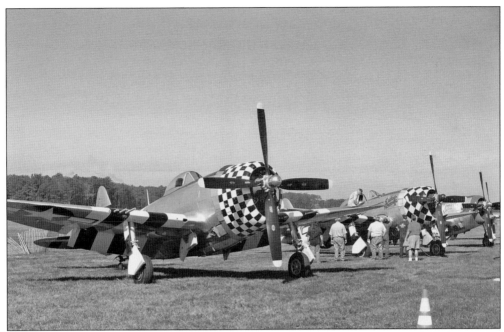

Once as thick as flies on the taxiway and above the field at Millville, P-47 Thunderbolts are now a rare breed. Fewer than ten Jugs still fly today. Visitors to the museum's air shows are usually greeted with at least one, if not more, of the planes that made Millville famous. In 2008, four Thunderbolts were featured at a World War II warbird display at Millville Airport.

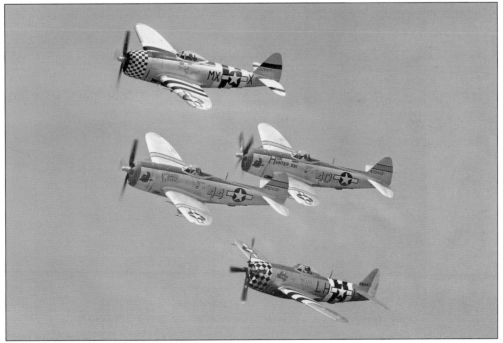

To see them in the air, though, is the real treat. In those instances, it is not only historic sights but also historic sounds that fill the sky. The roar of a Thunderbolt motor used to strike fear in the hearts of enemy pilots. Now it fills the hearts of spectators with pride.

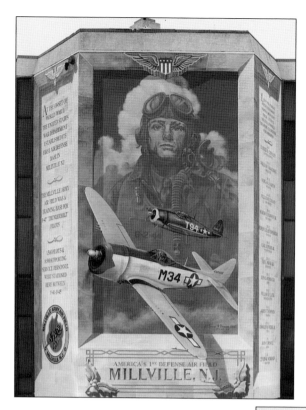

The story of the Millville Army Air Field belongs to the airfield, the city, and the nation as a whole. Dedicated in April 1998, the City of Millville's World War II Wall of Remembrance Mural stands three stories high on the north wall of Millville City Hall at High and Main Streets. It commemorates Millville's contribution to America's Second World War aviation history and honors fallen heroes.

Millville native 2nd Lt. Maurice W. (Marty) Garton, a fallen World War II P-47 pilot, is honored with a bronze plaque mounted to a five-ton boulder located in front of Millville's Wall of Remembrance Mural at city hall.

WINGS OVER MILLVILLE

On wings of silver through the
 sky
A lightly humming plane goes
 by,
And people stand, in awe, to
 see
This human bird so blithe and
 free!
The aviator's fragile wings
Bring visions of delightful
 things.
O glorious world! where men
 can fly
In God's illimitable sky.
The plane goes gaily on its way,
The busy people turn away,
But others look with wistful
 eye
Into the rosy, sunset sky.
Bright dreams and vague ambi-
 tions come
In answer to that distant hum.

Louise Scott Schick.

In the end, there is simply no way to tell the story of the Millville Army Air Field and what it has meant to the nation. Poets, journalists, and authors have tried, but how does one capture the sacrifice, heartbreak, and losses of World War II in mere words? The P-47 pilots, Millville flyers, gave America their best, and they deserve the country's best in return. That motivating spirit drives the staff and volunteers of the Millville Army Air Field Museum to strive for excellence.

www.arcadiapublishing.com

Discover books about the town where you grew up, the cities where your friends and families live, the town where your parents met, or even that retirement spot you've been dreaming about. Our Web site provides history lovers with exclusive deals, advanced notification about new titles, e-mail alerts of author events, and much more.

Find Your Place in History.